KLIMT

SCHIELE

KOKOSCHKA

Drawings and watercolours

KLIMT
SCHIELE
KOKOSCHKA

Drawings and watercolours

Introduction by Otto Breicha

Documentary notes by Christian Nebehay

with 170 illustrations, 17 in colour

THAMES AND HUDSON

This book was prepared under the direction of Ernst Goldschmidt as a catalogue for an exhibition held at the Palais des Beaux-Arts, Brussels, 4 April - 17 May 1981.

Translated by Mary Whittall

Reproduction rights:
Klimt: Verlag Galerie Welz, Salzburg Schiele: Ing. Norbert Gradisch, Vienna Kokoschka: Cosmopress, Geneva

First published in the UK in 1981 by Thames and Hudson Ltd, London

Printed and bound in Belgium

CONTENTS

Introduction 7

Select bibliography 24

GUSTAV KLIMT

Biographical notes 29

Catalogue 33

EGON SCHIELE

Biographical notes 77

Catalogue 81

OSKAR KOKOSCHKA

Biographical notes 135

Catalogue 139

Otto Breicha

Daring the Audacious

Vienna at the turn of the century was the scene of one of the most absorbing chapters in the history of the art and culture of modern times. It was the city, and the age, of Otto Weininger and Sigmund Freud. The contribution made to modern architecture by Otto Wagner and Adolf Loos is beyond dispute, although the importance of the villas designed by Josef Hoffmann, like that of the Wiener Werkstätte, the 'Vienna Workshops' for the promotion of modern arts and crafts, of which Hoffmann was a co-founder, has yet to be fully appreciated even now. Hugo von Hofmannsthal, Peter Altenberg and Arthur Schnitzler were by no means the only writers whose work was of more than local or transient interest and importance. It was in Vienna, in 1899, that Karl Kraus began publishing his polemical journal *Die Fackel* (The Torch), a red rag to a bull for some, a bible for others in all matters concerning literature, opinions and modern living. Not least, Vienna at that date was the cradle of developments that had a decisive effect on the music of the new century: Gustav Mahler, Arnold Schoenberg (and the latter's brother-in-law Alexander Zemlinsky) explored the heritage of Wagner, Brahms and Bruckner to uncover new worlds of musical emotions, new and unconventional principles and new technical means which were transmitted, considerably enriched by Schoenberg's pupils Anton Webern and Alban Berg, to the next generation. The Vienna of those days was the capital city of an empire made up of many races, and simultaneously a pulsating centre of commerce and intellectual exchange alike, of learning, the sciences and the arts. The life of the city, with all its weaknesses and strengths, was an intrinsic precondition, the necessary background, for all that was achieved there in those years, achievements that still stand today.

The Vienna Secession was founded in April 1897 by a group of progressive spirits and talents in the fine arts and architecture. It became the focus of general attention before the year was out with a sensationally successful first exhibition, which left no doubt of the group's declared opposition to the conventions of the art of the day.

The Secessionists erupted upon the scene, 'daring the audacious', as Ludwig Hevesi said of them. By 1898 they already had their own premises, designed by Olbrich, with an inscription over the entrance that proclaimed the association's programme and ideals: 'To the age its art, to art its freedom'. It also propagated its goals in a beautifully produced periodical *Ver Sacrum* (Sacred Spring); this saw, among other things, the first publication of Adolf Loos's polemical article 'Die potemkinsche Stadt'.

The Secession continued to put on well-prepared and lavishly mounted exhibitions (for example, of the French Impressionists, of Rodin, Munch and Hodler) and established by this means close relations with the other European art centres. In 1904 the Wiener Werkstätte were founded under the auspices of the Secession. Their first important commission was the Hôtel Stoclet in Brussels: this, designed by Josef Hoffmann, is one of the major works in the Viennese Art Nouveau style or Jugendstil. The cartoons for the mosaic decoration of the dining room walls were the work of Gustav Klimt. Klimt was from the first, as he remains to this day, the most prominent figure in the Vienna Secession, both as a personality and in his work. He was its first president. He was at the centre of the sometimes

The Secession building in Vienna, *c.* 1902. Architect J.M. Olbrich

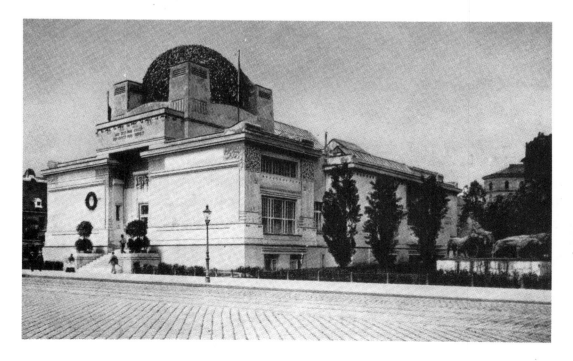

stormy controversy that broke out concerning the pros and cons of modernism. His ceiling paintings for Vienna University provoked an outcry that became known as the 'Klimt scandal'. There were other artists who aligned themselves with Klimt and seceded with him in turn from the Secession in 1905; it was at the Kunstschau exhibition which this breakaway group mounted three years later as a spectacular demonstration of their activities and their intentions that the young Kokoschka made his début. Even in his lifetime Klimt's work was highly esteemed by a not inconsiderable number of admirers. The purchase of his painting *The Kiss* for the Staats-Galerie in 1908, following its exhibition in the Kunstschau, was in a sense a token of public acceptance after the years of controversy during which his work had been at best sceptically tolerated.

The acceptance was of Klimt the painter, and in particular of a picture that represented the peak of his 'golden' style, the culmination of a development that had led from the fin-de-siècle romantic impressionism of, for instance, the picture of Schubert to the ornamental monumentalism of *The Kiss* and the use of a technique which Ludwig Hevesi, the leading 'front-line' critic, aptly termed 'painted mosaic'. 'Nature' here is something other than naturalism, realism increasingly moves away from Impressionism and the veiled depiction of the purely atmospheric towards stylization and Symbolism. Fin-de-siècle sensibility is channelled towards an entirely decorative principle.

It was different in drawing, which never lost that certain immediacy. Klimt drew a lot, all through his life. What survives of this activity remained for a long time wrongly underestimated and overshadowed by the painting, but is now increasingly coming to be recognized as a complementary part of his total oeuvre, and of no less artistic importance than the paintings. The drawings show works in the process of creation, the everyday concern with the real and the actual, the testing step by step of ideas, alternative possibilities and compositional and stylistic variants. But Klimt also drew in order to 'unwind' his eye and his mind, and relax after the hard labour of painting. Many of his most beautiful and perfect drawings were thus produced almost incidentally, yet there is a thrilling immediacy in the representation, a sovereign buoyancy in the treatment of the subject : this is an art 'of the little that is much'.

Almost exclusively, women constituted the subject matter of Klimt's drawings, naked or magnificently robed, posing with an intriguing turn to the body or wrapped in an embrace, sitting, standing, reclining. There is something unmistakably erotic in the improvisatory treatment of the subject, a tenderness both in the artist's attitude and in his realization. Franz Servaes has defined this as the 'Viennese quality of modern artistic feeling', exemplified by the 'tact of the hand which, while drawing a light veil over everything, delicately expresses everything'.

But for all their independent standing, the drawings are not to be divorced from the paintings to which they form an accompaniment, all the more so in the case of the production of the 1880s and 1890s, when all Klimt's works on paper were studies for his large pictorial compositions of the time. Thus, for his ceiling paintings in the new Burgtheater in Vienna, there are preparatory drawings of details of the members of the audience for the large gouache depicting the auditorium of the old Burgtheater. After the Burgtheater, Klimt moved diagonally across the Ringstrasse to decorate the new university buildings, and the difference between these two big public commissions epitomizes the transition from the conventionally successful artist in the manner of Hans Makart to the modernist and leader of the Secession; from the representative to the individual, from a skilful assimilation of historical models to a more and more personal conception of the artist's métier. As in the paintings, so in the drawings: the earlier ones are studies of models, draped fabrics, portraits, Romeo's head resting on a pillow, while the later ones use a stenographic technique to depict Art Nouveau robes, and nudes are elegantly elongated with undulating outlines; the execution at first taking pleasure in heightening details with white, then displaying an equal bent for intricacy and involution, for the particular resources in draughtsmanship that Art Nouveau encouraged. Drawing an allegory of the month of June, Klimt combines various techniques, as he was later to 'piece together' his paintings: hatching to model the faces, billowing outlines and stylized ornament (a gold vine encircling the head shown in profile in the square inset) (7).

In the years preceding the foundation of the Secession, Klimt used hatching as a means of bringing an object, a detail, forward from a dark background. In the sketches for Medicine, the first of the paint-

ings for the University (they were intended to represent the various academic faculties), the lines of hatching are drawn firmly across the figure, serving to define light and shade, the separation of the arm from the body, the swelling of the stomach.

Klimt's design for the poster advertising the first Secession exhibition (held in the spring of 1898 in the Floral Halls on the Parkring) naturally, in view of the occasion, pays whole-hearted.homage to the newest fashion (6). The figure of the goddess is drawn in strict profile and placed at the extreme edge of the picture, and there is a large area of empty space between the cornice, with its relief of Theseus slaying the Minotaur, and the lettering. Some idea of the stages that perhaps preceded this design can be gained from the numerous sketches and studies that exist for the later paintings of women : the first idea to be given shape is very imprecise, and then it grows into its eventual form by dint of being drawn over and over again ; thus it is only gradually that the figure of 'Expectation' (for the Hôtel Stoclet mosaics) evolves its distinct posture and profile (22, 23). This is

The dining room in the Hôtel Stoclet, Brussels, with the mosaics made from cartoons by Gustav Klimt

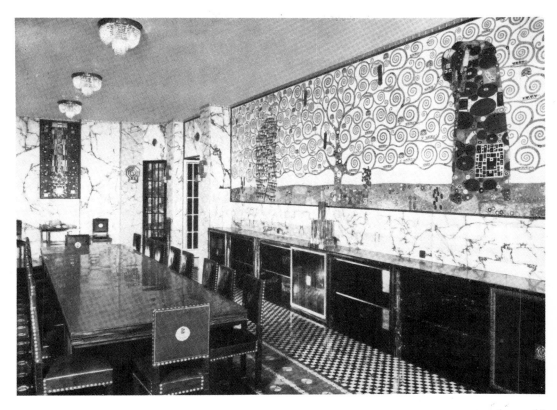

artistic creation caught in the act; only sketches have this beauty of instantaneousness and wilfulness. Studied purely for the nature of the draughtsmanship, the lines flow and curve and arch, draperies fall in rich folds, the artist wallows in an abundance of twists and curls. Where the painter would point telling contrasts between refined skin tones and sumptuous fabrics, the draughtsman has the freedom to veil and lay bare with equal refinement. Stockinged legs emerge from a wilderness of frills. The alternation of display and concealment creates a thoroughly erotic tension which draws the viewer into the game. Beauty in its beautiful unselfconsciousness, the artist as appreciative observer: curiosity as an artistic stimulus.

Klimt drew what he saw and was only too liable to yield to spontaneous impulses. The realist that he was when drawing gained strength and confirmation from the appearance of things. The great majority of his drawings are an act of homage to the 'naively sensual, nervous race' to which he himself belonged. It was not things of general significance that inspired him but the highly individual and special, and drawing was the appropriate medium for setting down the instantaneous and the transient. The undoubtedly programmatic titles of two books by Peter Altenberg, *How I see it* and *What the day brings me,* could also be used for most of Klimt's drawings.

The later drawings, those dating from about 1912 onwards, constitute a separate body of work. Possibly the longsightedness which Klimt developed is one reason why the outlines, once so firmly defined, now seem to be fraying. These years also saw the emergence in the paintings of a different approach to colour, brushwork and background, and the drawings came to be characterized by unexpected, dynamic placing of the axes, poses of extreme physical energy, fluttering draperies and busy hatching. These characteristics gained for the style of the following years the epithet of 'bacchanalian', and it was not until nearly the end of his life that Klimt's style quietened down again and achieved that great, lucid moderation by which Klimt the draughtsman is elevated above all transient stylistic fashions.

In 1902 Klimt painted some murals (subsequently taken down) to decorate the Secession building for the occasion of the exhibition of Max Klinger's statue of Beethoven. The style of this so-called 'Beethoven Frieze' was strongly influenced by his drawing, which at that

stage was more mature than that of his contemporary painting. In some respects the frieze served as both catalyst and model for the development that is rather imprecisely termed 'Austrian pre-Expressionism'. For Klimt personally this monumental work represented a step of major importance on the road towards his own individual style. He, at least, had never before made such a drastic and uncompromising use of the resources of Art Nouveau, and furthermore nobody had ever before instilled such emotional intensity into the fluid line of Secessionist curvature. The line itself is both the means of representation and the vehicle of expression at the same time. That part of the composition which caused the greatest outcry at the time (the 'hostile forces') is what strikes the modern eye as the most successful of all. There survive a large number of illuminating preliminary drawings for the three female vampires on the left of the group (9). Even after the passage of several years, their tense pose and expressive modelling (filled with 'a Toorop-like lust for penitence and a Minne-like epicurism in exhaustion', as Hevesi observed) had a direct and decisive influence on Egon Schiele and Oskar Kokoschka in the fashioning of their individual concepts of Expressionism. There were two things in particular that impressed Klimt's younger admirers in the *Beethoven Frieze*: the unnaturalistic drawing, heightening the expressive force, and the new type of figures, which shock both through their appearance and for what they represent. The elongation of figures, which was an Art Nouveau ideal, was already put to use by Klimt as a decorative expression of a state of mind. And Schiele, in particular, starting from an acceptance of the stylistic schematicism of the Vienna Secessionists, adopted this kind of aggressive concentration on angles and outlines quite literally.

The names of Klimt and Schiele are commonly and regrettably bracketed together with rather more emphasis than is warranted. Their surviving work amounts to somewhat more than a view from different sides of related natures or similar responses to existence. Nor can their relationship be expressed by a simple formula such as that of teacher and pupil. At the age of eighteen, Schiele undeniably was impressed by the paintings of Klimt's early Secessionist period and obviously was influenced, in his own style of drawing, by the *Beethoven Frieze*. For Klimt himself these years and these works represented stages in his rejection of tradition and a fundamental

stylistic renewal, but his work never lost a ceremonial character. The 'sacred spring' proclaimed by the Vienna Secession is distinguished only by externals from the self-confidence of those who built and ornamented the Ringstraße (a group which included the Klimt brothers). Throughout his life Klimt's objective remained the evocation and advocacy of beauty in every context. Even when he touched on the 'last things', when his subjects were evil, suffering and death, stylization and colouristic refinement make them good to look at. His fundamental sympathy for the beauty of women and the world did not exclude transience and decay from his reckoning, but he was able to glorify even menace and revulsion.

It was different with his 'pupils' Schiele and Kokoschka. Of the two, Schiele was closer to their mentor to begin with, but he soon became aware of a totally different perspective. Intellect was merely a grimace in his view of things, life the sickness preceding death, its burdens and pressures compulsion and predestination. The whole world labours under a consciousness of fate. Existence is misfortune, painting a pouring out of the Holy (or Unholy) Spirit on to canvas.

To take the place of the qualities and criteria he abandoned, he adopted new and very different ones originating beyond the traditional norms of the good and the beautiful. What was conventionally regarded as the 'truth' of a work of art was subject to alteration and uncertainty as taste and style change with the passage of time. The world of Klimt's art was far from 'sound' or 'wholesome' but it was still informed with a compulsive beauty: Schiele's art was a far closer accompaniment to the 'experimental laboratory for the end of the world', as pre-1914 Vienna has been called. It is a revelation of advanced decline, an end is near, catastrophe is in the air; between the two poles of sensibility and expressiveness, nothing could be more opposed to the affirmation and promise of Klimt. Martyrs, hermits, fakirs, such as deny life and such as are condemned to life are exposed in imaginary, charged locations, and the motive for their elevation from detailed individuality into broad generality is anything other than the cause of decorative synthesis.

In all, the appearance on the scene of the Viennese pre-Expressionists Kokoschka and Schiele signified the establishment of a genuinely avant-garde position, of more than merely Austrian significance. The admiration for Klimt was in a sense inevitable, but by their

early twenties they freed themselves, almost without going through a stage of transition, from all dependence on his example. Viennese Expressionism took its bow in public with the exhibition in 1908 of Kokoschka's life-size tempera studies for *The Bearers of Dreams* at the Kunstschau organized by the 'Klimt group' of secessionists from the Secession. Within the space of another year and a half, Schiele had caught up and drawn level with Kokoschka as painter and as draughtsman, in figure drawing and in landscape. The 'Chief Savage' of the Kunstschau had been joined by a 'Gothicist', who revealed himself as such in monumental nudes, hallucinated landscapes and gross portraits. By the time, a year or two later still, that Expressionism had become the fashion for the progressive artist, Schiele had already long been occupying himself with different, no less startling issues: cubistically splintered drawings, town views from the steepest of angles, a robust energy partnered with a new, more vital colourism. In February 1918, only a few months before his own death, he drew the dead Klimt; the drawing is not the least 'ghostly', not the least 'expressionistic', it portrays a human face that has been extinguished, has taken leave of itself. It is a long way from the confessional double portrait of the two hermits, crowned with thorns and with their dreams, clutching and supporting each other; and even further from the postcard-size drawing of Schiele and his teacher in the Secessionist meadow, flowers at their feet and halos round their heads. Ten years lay between that drawing and the study of the dead Klimt. The harvest of those years was a life's work that was in no way inferior to that of the teacher, indeed surpasses it in certain respects, in incisiveness and certainty of purpose. And at no point did Schiele behave more purposefully or incisively than when the cast himself off from Klimt's influence in 1909-10, in order to come to terms with his own artistic identity.

Both Klimt and Schiele were uncommonly prolific draughtsmen, but their drawings are as different as the temperaments and backgrounds of their art, both in manner of execution and in their inspiration and aims. Klimt drew to improve his technical facility, to exercise his eye and skill; Schiele drew in order to be able to express and realize himself in black and white or in watercolour as he did in oil. Klimt's drawings are studies above all else, an element that is totally irrelevant to Schiele's drawings. Klimt drew in order to set himself

along the right road, Schiele to define something initially hard to assess, to carve out the most effective course from the many possibilities. Klimt was an epicurean and a virtuoso, of a taurine vigour. His effort to capture the desired motif in a drawing is like throwing a lasso: his line snakes round the object, gives a sudden jerk and uncoils, twisting round knots and stitches, tacking along pleats and contours until, dazzled by its own trajectory, it peters out in trifles. Before painting a portrait, Klimt drew dozens of studies of different poses, until he had the composition in his head and ready to go down on the canvas. He drew like one enraptured, flirting with his subject, caressing her body like a lover, at once pliant, careless, audacious, intent on turns and formations for which speed and flexibility were the essential prerequisites.

In point of subject matter Schiele spread a far wider net. He drew, or painted in watercolour, everything he needed: flowers, trees, the walls of Krumlov, the scenery of the Wachau and the Vienna Woods; among all these the human face and figure were only one subject — though still the most important. Schiele's portraits and nudes, and in particular his drawings in that field, are scarcely equalled by anything else in the whole of Expressionist art. Seizing on the essentials, as he saw them, and holding them up to mocking scrutiny, Schiele portrayed his friends, fellow artists and buyers, but above all himself, posing, gesticulating, his fingers splayed, his hair tousled (as he sometimes also posed for the photographer, leaning against a picture as if he was a figure in the composition). In yellow and green, red and purple, he made watercolour sketches of babies, female models and large-eyed ragamuffins, and also of celebrities like the architect Otto Wagner. Schiele's drawings are a living demonstration of the proposition that art makes visible what others do not see, what lies concealed. Exaggeration and distortion are plainly not accidental, or done for wanton effect; they are intrinsic, serving both metaphorical and literal interpretation.

An animate spirit obtrudes as forcefully in Schiele's drawings of flowers, trees and houses as it does in his portraits. They are brimful of life, possessed by moods and emotions, intent on arousing the same feelings in the viewer. The same is true of his paintings. They are the visual expression and representation of experiences and strong emotions, and it is only in the context of the picture, in the

associations in which the artist brings them together, that the separate objects become what they stand for: symbols of special beauty and horror that the artist has lived through, the at once beautiful and terrible ecstasy of stepping out of one's own persona.

Just as the subjects, the essence and the styles of the two artists are fundamentally distinct, so too their techniques should not be confused: with Klimt what is fluent, surging and compliant is always entrusted exclusively to his supple line, whether he uses pencil or crayon; with Schiele line is a scaffolding that both carries and is strengthened by colour. Line is a decision made, a knife unsheathed. Colour throbs and festers like a wound.

Two very different ways of regarding the world, two very different moods: Vienna, the city where Sigmund Freud lived and taught, was not fully represented by the palaces and splendid public buildings along the Ringstrasse. Behind the house-fronts of a self-confident and self-seeking society there lay suppressed all too much that was apt for appropriation by a young and impatient movement of 'modern' artists. The 'sacred spring' of the Secessionists had been the all too optimistic attempt to bring about a renewal of life in all its aspects; the Kunstschau exhibitions, at which Kokoschka and Schiele first showed their work, were a last attempt by Klimt's circle to present to the world at large their conception of a synthesis of all the arts. The Garden Theatre attached to the Kunstschau presented two plays by the twenty-two-year-old Kokoschka, including his playlet *Murderer, Hope of Women,* which anticipated the Expressionist drama in all its essentials. The play derives its motive force from the unleashing of all urges and instincts. Kokoschka's poster for it (p. 36) is a garish *pietà,* with distorted limbs and violent colours, which goes technically and expressively far beyond his book *The Dreaming Youths,* done for the Wiener Werkstätte and dedicated to Klimt. This dithyramb to the exotic and the ecstatic possesses a rare penetrating force that can be experienced even now, three-quarters of a century later: it is an act of self-communing addressed to the whole world, in which intensity takes the place of the assemblage of beauty. Art was beginning 'to speak apocalyptically', wrote the young poet-painter Albert Paris von Gütersloh in 1911 of Egon Schiele, then all of twenty-one years old.

In 1908, when the Austrian capital celebrated the emperor's diamond jubilee with a ceremonial parade all round the city, Emil Klagen published a book with the title *Through the Viennese Quarters of Misery and Crime*. Its few readers (none of whom were much impressed by it) were told of 'another' Vienna, of a population that lived in the sewers beneath that very Ringstraße along which the triumphal parade passed in a determined effort to revive and even surpass the glories and the pomp of the age of Makart. Freud's investigation of the subconscious and the unconscious was paralleled in the art of Kokoschka and Schiele, which was concerned with the essence behind appearances, with 'another' kind of truth. An inner truth, expressed through the medium of an art that necessarily made a new sound. Assertion and action react upon each other. What if the form is abnormal? It is to a certain extent (and unfailingly) the spirit which 'builds the body'. Most contemporaries, having shared the experience, hounded the art as 'negative', psychotic, ugly and tormented, or downright pornographic, but the form merely obeys rules, long since sanctioned, in answer to the vision that an unbeautified reality presented to young, urgent artists. The charges laid against the age and its morality, its literature and its lies by the critic and nay-sayer Karl Kraus, to the accompaniment of the passionate adulation of his mostly youthful adherents, correspond exactly to the denunciations expressed in the art of Kokoschka and Schiele (for whom the truth of the charges was horrifyingly and generally confirmed in 1914). Their portraits and allegories are the earliest and most emphatic expression of what lies beyond and under the surface, the essence concealed in the appearance, the beast lurking in our lives and our relationships — but also of the claims of suffering, the dignity and the beauty of ugliness.

Expressionism depicts 'experience in life', Kokoschka told Edvard Munch many years later. Thus even the portraits and landscapes from that time when the Expressionists 'were still right' have experiences embodied in them: the boldly different, the moved, the ambivalent (Kokoschka's superimpositon of different views of a head in a single portrait drawing), a nervous *morbidezza*, the stigmatized and tragically isolated (Schiele's drawings of bodies inclining across the picture area), the constricted and confined; outlines that buckle and suppurate (instead of soaring and swaying as in Klimt); bodies pieced

together from splinters of colour or surrounded by white gouache like an aura. The self-portrait, virtually absent from Klimt's output, becomes a major theme with his successors: what more appropriate subject for the artist intent on expression than the exploration and interrogation of himself, living and breathing, drawing and probing? Such a subject is the next best thing to the reality of experience, prudently formed and interpreted in accordance with the demands of discretion and truth; drawing (and painting) can express the inner fervour of existence and acknowledge existential responsibility.

Kokoschka's début at the Kunstschau demonstrated his adventurous spirit and readiness to take risks. The page of drawings which was purchased to mark the imperial jubilee (99) also shows that, unlike the young Schiele, he was only very superficially touched by the stylization that was one of the hallmarks of the Secession. Among stiff flowering trees, and a bird flying out of a cage, there are several standing figures in holiday dress, their bodies eloquently twisted; while the composition of *Mother with Child* (98) still lingers in the imaginative world of *The Dreaming Youths,* in this picture Kokoschka enters the world of Expression.

From this same period date the drawings of nude child acrobats, undertaken as experiments in grasping and 'uttering' the movement of the moving figure. The stylistic distance between these drawings, some of them tinted with pale washes, and Klimt's studies for the *Beethoven Frieze* is the measure of their individuality and independence.

The poet Else Lasker-Schüler called Kokoschka 'an old master, born late' and 'a terrible wonder'. An angry wonder and some terror were the reactions with which the works of the first (Expressionist) decade of his production were received. Yet even in these earliest works there is a clear and unequivocal declaration of the affiliations that were to remain important to the artist throughout his career. Consciously and conscientiously, Kokoschka always acknowledged his love for the masters and examples who had influenced him most, from Pacific Islanders to the joyous colour with which the Baroque masters decorated the interiors of their churches. For all the revolutionary élan of his work he never abandoned the framework of portrait, landscape, still-life and group composition, but more or less deliberately applied himself to emulating and surpassing his models.

Egon Schiele
Schiele and his teacher (Klimt?).
Design for a postcard, not carried out (1909)

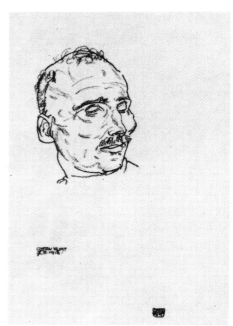

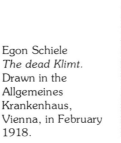

Egon Schiele
The dead Klimt.
Drawn in the
Allgemeines
Krankenhaus,
Vienna, in February
1918.

The character and qualities of this prodigy of early-twentieth-century Austrian art are better understood, in fact, in the light of comparison with the past than with the contemporary scene of his youth.

Kokoschka's celebrated early portraits constitute a last and major contribution to the classic European tradition. This is equally true of his drawings, for instance the portrait of Karl Kraus of 1909-10 (112). The medium of brush and india ink enabled him to go straight to his sitter's soul. And yet this is not the expected impression of a fiery spirit haunted by satiric visions, but the suggestion of a thoughtful introvert, with head bowed and hand raised as if defensively. There is a pronounced emotional disquiet not only in the drawing but even in the very pose, with the head almost in full profile, while the body squarely fronts the viewer, creating great expressive intensity. Kokoschka's drawing technique underwent a process of extreme radicalization, beginning while he was still in Vienna, but especially after his move to Berlin, where he went to work on Herwarth Walden's Expressionist periodical *Der Sturm*. In his illustrations to Albert Ehrenstein's tale *Tubutsch* and above all in some of the title-page designs for *Der Sturm* the draughtsmanship is so frayed and speckled that it verges at times on the non-figurative.

But essentially Kokoschka was the outstanding portraitist of the personalities in the intellectual circles in which he moved: actresses, the poet Peter Altenberg, the architect Adolf Loos, Herwarth Walden and the writers he published. In October 1920 Kokoschka, by then thirty-four, drew a self-portrait that was very different from its predecessors, not in the least assertive or accusatory (133): a young man, with a large head, putting his physiognomic appearance down on paper with a new, alert interest in objective, naturalistic representation. As Schiele drew the dead Klimt, so Kokoschka drew a friend's newly dead father, with not the least trace of the uncanny or the symbolic (in spite of the inscription 'Omnia vana' at the top of the sheet). Death here is the absence of life, a fact to be accepted as unremarkable, and not generalized into something of immense human significance as it is in the drawings he made on the subject of Bach's cantata 'O Ewigkeit, du Donnerwort'.

It was also in 1920 that Kokoschka did the series of large-format drawings collected in the portfolio *Variations on a theme*. They all depict the wife of the art historian K.M. Swoboda listening to music. Once again, there is no attempt to 'explain' but simply to 'show' the changing effects of music on the sitter's appearance. Nervous tension and psychological insight are still features of these drawings, but they are absorbed as far as may be into the phenomenological study.

Such truth to nature was a new departure for the young Kokoschka, taking him in a relatively Baroque direction towards the greater openness and interest in the material existence that also predominate in the exuberant colour and intensely painterly technique of the paintings and watercolours of the same period. An essentially similar spirit, though with some differences, determined Schiele's drawings and watercolours from about 1916 onwards, though in Schiele's case the influence of Hodler may have played a part. Undoubtedly Schiele had it in mind to sell some of these drawings, which are therefore much more finished than otherwise. Nevertheless there is no mistaking a general similarity of approach, a turn towards the sensual and material which appears to reverse the previous Expressionist renunciation of such phenomena. What is probably Schiele's very last work, when he was himself mortally ill, is the drawing of his dying wife. In spite of the emotion inherent in the situation, it is strangely absent from the drawing itself, as if it were just another portrait.

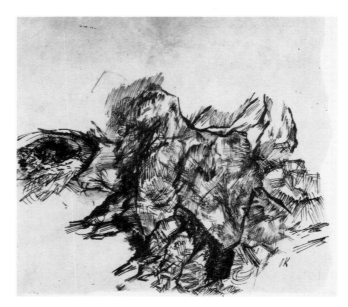

Oskar Kokoschka
Recumbent woman. Drawing
for *Der Sturm*. Basle,
Kunstmuseum,
Kupferstichkabinett

Oskar Kokoschka
One of the drawings
reproduced in the portfolio
Variations on a theme (1921)

Not that Expressionism, by then the height of artistic fashion, had shot its bolt. The artists who had introduced it in Vienna ten years previously had discovered new goals and purposes and consequently their work shows changes in manner and style, but they were as wholehearted and honest as they had been in the exploration of Expression.

Klimt, Schiele and Kokoschka, together with the works they bequeathed to us, have long ceased to be an exclusively Austrian concern. Their fame and acclaim are world-wide, and they are judged on an equal footing with their peers, with everything that is best in early-twentieth-century art. Each of them produced an oeuvre that, while it has its place in art history, requires no special knowledge to understand or appreciate. What they set down on paper sixty, seventy and eighty years ago could have been drawn yesterday. Much, indeed most, of what then germinated in, and because of, the work of these three great artists is still astonishingly alive, in itself and in what it stands for. It is a human reality, the convulsive landscape of the suffering and passion, the searching and longing of souls released from confinement by art to work and to endure.

SELECT BIBLIOGRAPHY

GUSTAV KLIMT

Books

NOVOTNY, F. and DOBAI, J., *Gustav Klimt*, London 1968 [incl. catalogue raisonné of Klimt's paintings].

STROBL, A., *Gustav Klimt. Zeichnungen und Gemälde*, Salzburg 1962/1976 (Eng. trans. as *Gustav Klimt. Drawings and Paintings*, New York 1976).

NEBEHAY, C.M., *Gustav Klimt. Sein Leben nach zeitgenössischen Berichten und Quellen*, Vienna 1969.

HOFMANN, W., *Gustav Klimt*, Greenwich, Conn. 1971 (trans. from Ger.).

KLIMT, G., *One Hundred Drawings* (introduction by A. Weiner), New York 1972.

COMINI, A., *Gustav Klimt*, London and New York 1975.

KLIMT, G., *Gustav Klimt* [a poster book], New York 1976.

BREICHA, O. (ed.), *Gustav Klimt, Die goldene Pforte*, Salzburg 1978.

HOFSTÄTTER, H.F., *Gustav Klimt Erotic Drawings*, London 1980.

STROBL, A., *Gustav Klimt. Die Zeichnungen 1878-1903*, Salzburg 1980.

Catalogues

Gustav Klimt. Egon Schiele. Zum Gedächtnis ihres Todes vor 50 Jahren. Zeichnungen und Aquarelle, Albertina, Vienna 1968.

Gustav Klimt, Henri Matisse, Mathildenhöhe, Darmstadt 1970.

Gustav Klimt 1862-1918: Drawings, New York 1970.

Gustav Klimt. Zeichnungen aus Albertina- und Privatbesitz, Museum Folkwang, Essen 1976.

EGON SCHIELE

Books

GÜTERSLOH, P. VON, *Egon Schiele, Versuch einer Vorrede*, Vienna 1911.

KARPFEN, F. (ed.), *Das Egon Schiele Buch*, Vienna 1921.

ROESSLER, A., *Erinnerungen an Egon Schiele*, Vienna 1922 (2nd edn 1948).

FAISTAUER, A., *Neue Malerei in Österreich, Betrachtungen eines Malers*, Vienna 1923.

BENESCH, O., *Egon Schiele als Zeichner*, Vienna 1950.

MITSCH, E., *Egon Schiele. Drawings and Watercolours*, New York 1976 (trans. from Ger.).

BENESCH, H., *Mein Weg mit Egon Schiele*, New York 1965.

COMINI, A. (ed.), *Schiele in Prison*, London and New York 1973 [trans. of document purporting to be Schiele's prison diary].

COMINI, A., *Egon Schiele's Portraits*, London and Berkeley, Los Angeles 1974.

MITSCH, E., *The Art of Egon Schiele*, London and New York 1975 (trans. from Ger.).

WILSON, S., *Egon Schiele*, Oxford 1977.

NEBEHAY, C., *Egon Schiele, Leben, Briefe, Gedichte*, Salzburg and Vienna 1979.

WHITFORD, F., *Egon Schiele*, London and New York 1981.

Catalogues

Egon Schiele, Marlborough Fine Art, London 1964.

Gustav Klimt and Egon Schiele, The Solomon R. Guggenheim Museum, New York 1965.

Egon Schiele, Leben und Werk, Historisches Museum der Stadt Wien, Vienna 1968.

Gustav Klimt. Egon Schiele. Zum Gedächtnis ihres Todes vor 50 Jahren. Zeichnungen und Aquarelle, Albertina, Vienna 1968.

Egon Schiele. Drawings and Watercolours 1909-1918, Marlborough Fine Art, London 1969.

Egon Schiele and the Human Form, Art Center, Des Moines 1971.

Egon Schiele 1890-1918, Fischer Fine Art, London 1972.

Egon Schiele. Gemälde, Aquarelle, Zeichnungen (compiled by R. Leopold), Salzburg 1973.

Egon Schiele 1890-1918, Haus der Kunst, Munich 1975.

Egon Schiele. Watercolours and Drawings, Marlborough Fine Art, London 1979.

Egon Schiele 1890-1918. Heimkehr nach Tulln. Werke und Dokumente aus Familienbesitz, Rathaus, Tulln 1980.

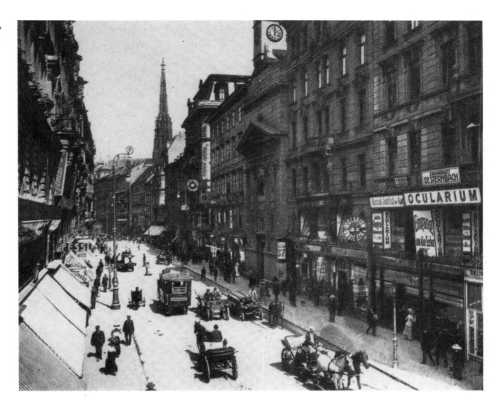

The Kärtnerstraße in Vienna, *c.* 1900, looking towards the spire of St Stephen's

OSKAR KOKOSCHKA

Books

HOFFMANN, E., *Kokoschka. Life and Work,* London 1947.

WINGLER, H.M., *Oskar Kokoschka. The Work of the Painter,* London 1958 (trans. from Ger.).

BULTMANN, B., *Oskar Kokoschka,* London and New York 1961 (trans. from Ger.).

GOLDSCHEIDER, L., *Kokoschka,* London and Greenwich, Conn. 1963.

KOKOSCHKA, O., *Oskar Kokoschka. Watercolours. Drawings. Writings* (introduction by J. Russell), London 1962, New York 1963.

BOSMANN, A., *Oskar Kokoschka,* New York 1964 (trans.).

HODIN, J.P., *Oskar Kokoschka : The Artist and his Time,* Greenwich, Conn. 1966.

SCHMALENBACH, F., *Oskar Kokoschka,* Greenwich, Conn. 1967 (trans.).

RATHENAU, E. (ed.), *Oskar Kokoschka Drawings 1906-1965,* Florida 1970 (trans. from Ger.).

GATT., G., *Kokoschka,* London and New York 1971.

KOKOSCHKA, O., *Mein Leben,* Munich 1971 (Eng. trans. as *My Life,* London 1974).

FENJÖ, I. and BETHUSY-HUC, R. (eds), *Oskar Kokoschka. Die frühe Graphik,* Vienna 1976.

Catalogues

I. Internationale der Zeichnung, Mathildenhöhe, Darmstadt 1964.

Oskar Kokoschka. Aquarelle und Zeichnungen, Graphische Sammlung Staatsgalerie, Stuttgart 1966.

THE ARTISTS
AND THEIR WORKS

The notes on the works are based on material supplied by the owners, supplemented by information drawn from books and exhibition catalogues; these are included in the select bibliography on pp. 24-5.

The order of the works under each artist is chronological, subject to certain technical and aesthetic considerations.

As Klimt and Schiele both died in 1918, the selection from Kokoschka's works was also limited to the first two decades of the century.

The documentary section at the head of each part is the work of Professor Christian M. Nebehay.

We are also greatly indebted to the curators of public collections, and the private collectors, who have given us so much practical help and advice.

Measurements are given in centimetres, with height preceding width.

E.G.

GUSTAV KLIMT

Gustav Klimt was born on 14 July 1862, the son of an engraver who often found it a struggle to feed his seven children. At the age of fourteen he went to the Kunstgewerbeschule in Vienna, where he stayed for seven years (1876-1882). For a while he remained completely under the influence of his teachers, all of whom are now forgotten. It was not until 1898 that he found his own personal style (*Portrait of Sonja Knips*, Österreichische Galerie, Vienna). He became a highly paid society painter, and an important landscape artist. He painted exceptionally slowly. He relaxed by drawing professional models, who were always present in his studio. He was undoubtedly one of the best draughtsmen of his generation. There survive something like 4500 drawings by him, very few of which are properly finished or signed, as he lived from the sale of his oils, not of his drawings. His most important works were the subject of violent controversy (three paintings representing the faculties of medicine, philosophy and jurisprudence, for the Great Hall of Vienna University, 1900-07, destroyed by fire in 1945 in the place to which they had been taken for safety). The university professors had expected him to paint large symbolic figures, and were upset by the many-peopled allegories he painted instead. Many viewers were further offended by the nudity of the 'hostile forces' (Lust, Immoderation, Unchastity etc.) in his *Beethoven Frieze* (1902). The emperor three times refused to permit him to be appointed professor at the Academy, although in 1898 he had expressed his 'All-highest recognition' of Klimt's murals for the stairways of the Burgtheater and the Kunsthistorisches Museum. Now, however, the court did not approve of his new style. Klimt worked alone and had no pupils. He died on 6 February 1918, at fifty-five.

Klimt's birthplace in the 14th district of Vienna (demolished 1967). The family lived in the apartment on the right of the gateway. Klimt, his younger brother Ernst, who died young (1864-92), and Franz Matsch (1861-1942) formed a 'Company of Artists', working together on the interior decoration of theatres. The youngest Klimt brother, Georg (1867-1931), was a sculptor, and executed the metal frames for some of Gustav's paintings and the bronze doors for the Secession building in Vienna.

Klimt contributed to numerous international art exhibitions. His *Theatre at Totis* was shown in Antwerp in 1893, his *Philosophy* in Paris in 1900, but neither of them aroused the least interest. His efforts to make a name for himself in Germany (fourteen exhibitions) were defeated by the disapprobation of the critics. His name is not even mentioned in much of the writing on art of the time.

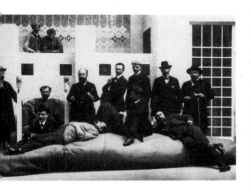

Dissatisfaction with the hanging committee of the Künstlerhaus in Vienna led a group of younger artists to gather around Gustav Klimt. The Vienna Secession was found in 1898. For as long as the 'Klimt group' remained associated with it (until 1905), the Secession held twenty-two exhibitions, all of which aroused great public attention, provided an opportunity for young artists to show their work, and introduced modern art to Vienna. In 1902 the Secession mounted a spectacular reception for Max Klinger's statue of Beethoven, regarded as a major work of modern sculpture. Klimt painted his *Beethoven Frieze* for the left hall in the Secession building for the occasion. He is seen here (seated, left, in the back row) with the other artists involved in the decoration.

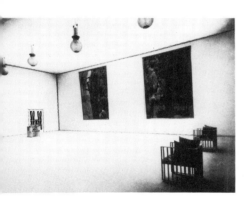

Far too much material was included in the early Secession exhibitions, but after 1900 new methods of hanging revolutionized exhibition techniques. The photograph shows the main room in the Klimt exhibition of 1903, organized by Koloman Moser (1868-1918). *Medicine* and *Philosophy* hang on the walls.

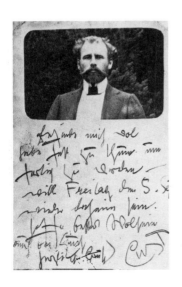

'I'm not good with words, written or spoken, especially not when I'm supposed to pronounce on myself or my work… Anybody who wants to find out about me — as an artist, the only thing that deserves any interest — is advised to look attentively at my paintings, and try to find out from them what I am and what I want to do.' Klimt usually conducted his correspondence on laconic postcards. In 1904 he sent his mother, with whom he lived, the mis-spelt card on the left, from the Attersee: 'Am well, still have a lot to do — will be home again Friday 5 Sept. Hope all at home well too. Best wishes, Gust.'

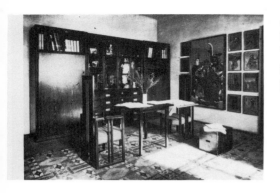

Ante-room in Klimt's second studio, at Josefstädterstrasse 21, Vienna VIII, in 1907. Furniture by Josef Hoffmann. The cupboards contain costly Chinese silk robes. Motives from the oriental woodcuts on the walls are to be seen in the backgrounds of his portraits from 1912 onwards.

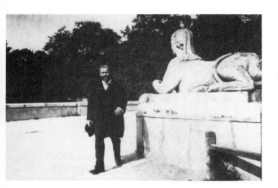

Klimt used to meet his friends every morning at the Tivoli Dairy near the palace of Schönbrunn, where, according to eye-witnesses, he consumed mountains of whipped cream. He forbade conversation about art. The photograph shows him on his way to the dairy in 1914, passing an imperial sphinx.

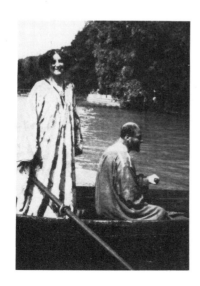

Klimt never married. For many years he was a close friend of his sister-in-law Emilie Flöge who, with her sisters, ran one of the leading fashion houses in Vienna. He also designed clothes for her. She did not like the portrait he painted of her (1902, Historisches Museum, Vienna). From 1900 he spent nearly all his summer holidays at her house on the Attersee in Upper Austria. He was an extremely shy person, and in order to paint undisturbed he often went out on the lake in a rowing boat.

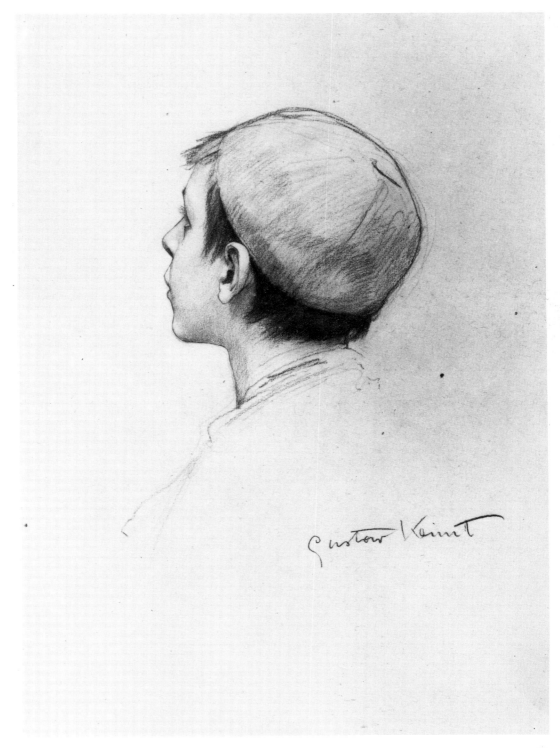

1
Boy in lost profile
Knabe im verlorenen Profil
Black chalk
44.0 × 31.0
Signed: *Gustav Klimt*
Study for *Romeo and Juliet*
ceiling panel for the
Burgtheater (1886-88)
Vienna, Graphische
Sammlung Albertina
(Inv. 27929)

2
Profile and back view of a man with opera glasses; sketch of right hand
Profil- und Rückansicht eines Herrn mit Theaterglas, Skizze der rechten Hand
Black chalk heightened with white
43.1 × 27.5
Monogrammed: *G.K.*
Study for *Auditorium of the Old Burgtheater* (1888-89)
Vienna, Graphische Sammlung Albertina
(Inv. 27928)

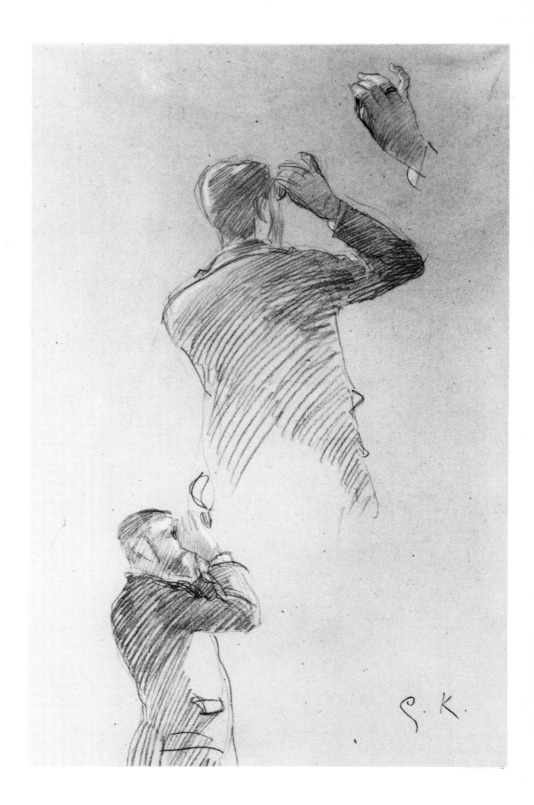

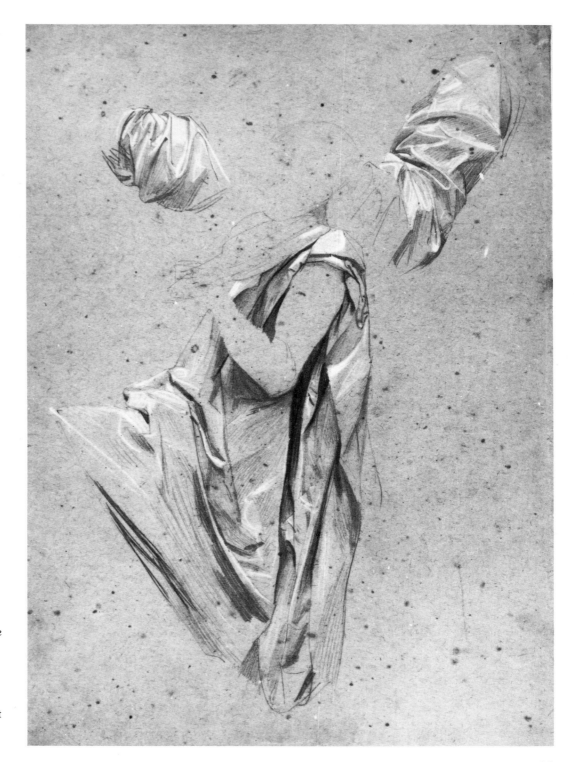

3
Study of drapery
Gewandstudie
Pencil heightened with white
45.0 × 31.5
Study for violinist in ceiling
panel *The Dance* for
Stadttheater, Karlsbad
(Karlovy Vary)
Linz, Neue Galerie der Stadt
Linz - Wolfgang Gurlitt
Museum

4
*Composition study, sketch
and detail study for 'Allegory
of Sculpture'
Kompositionsentwurf, Skizze
und Einzelstudie für die
Allegorie der Skulptur*
Pencil
43.0 × 30.5
Vienna, private collection

36

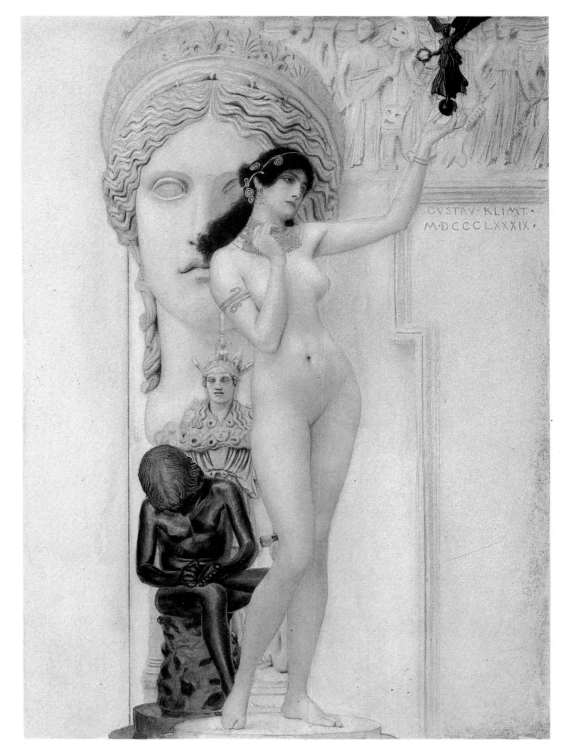

5
Allegory of sculpture, 1889
Allegorie der Skulptur
Pencil and watercolour
heightened with gold on card
43.5 × 30.0
Signed: *GUSTAV KLIMT*
MDCCCLXXXIX
Appears on folio 20 of the
address of homage presented
by the Kunstgewerbeschule to
its patron, Archduke Rainer,
to mark the 25th anniversary
of the founding of the
Museum
Vienna, Österreichisches
Museum für Angewandte
Kunst

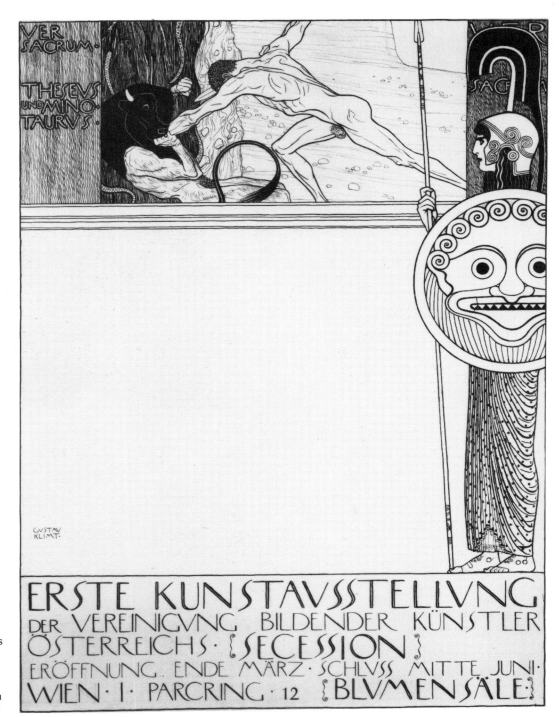

6
Finished drawing for the poster of the first Secession exhibition, 1898
Reinzeichnung für das Plakat der ersten Secessionsausstellung
Pencil drawing finished in india ink with pen, corrections in process white
130.0 × 80.0
Signed: *GUSTAV KLIMT*
Vienna, Historisches Museum der Stadt Wien (Inv. 116210)

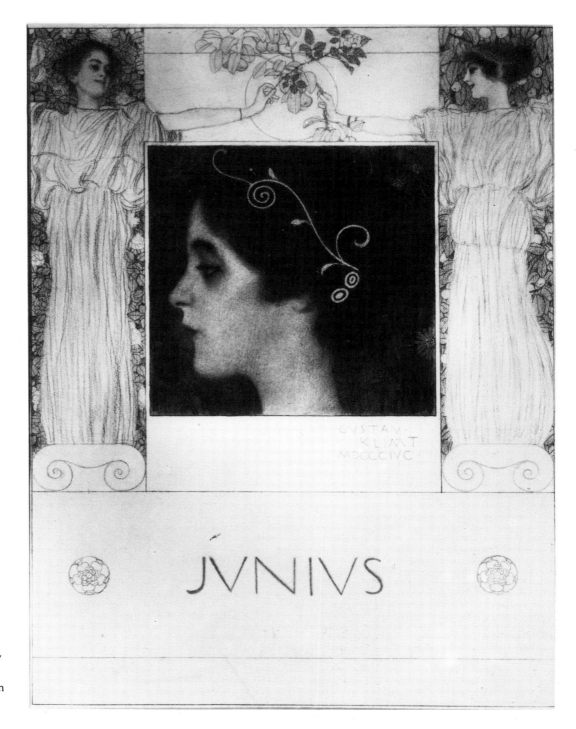

7
*Finished drawing for the
'Allegory of June', 1896
Reinzeichnung für die
Allegorie Junius*
Black chalk, pencil stumped,
wash, heightened with gold
41.5 × 31.0
Signed and dated: *GUSTAV
KLIMT MDCCCIVC*
Vienna, Historisches Museum
der Stadt Wien (Inv. 25016)

8
Seated man
Sitzender Mann
Black chalk and watercolour
heightened with white
45.0 × 31.3
Stamp of Estate
Study for *Schubert at the
Piano I* (1899). The pianist
has not yet taken on
Schubert's features.
Vienna, private collection

9
Standing girl
Stehendes Mädchen
Black chalk, hair stumped
45.0 × 30.4
Monogrammed: *G.K.*
Inscribed: *R*
Study for one of the Gorgons
in the *Beethoven Frieze*
(1902)
Private collection

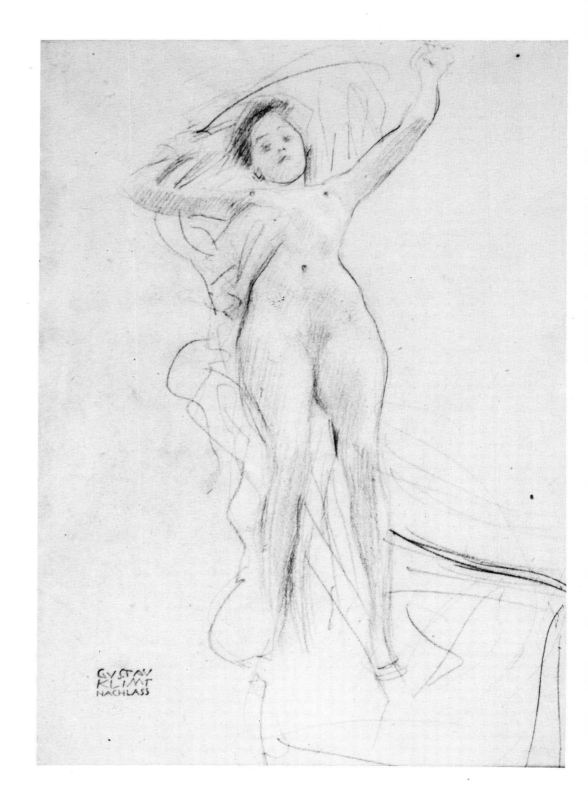

10
Girl floating in air
Schwebende
Pencil
43.0 × 30.5
Stamp of Estate
Brussels, private collection

42

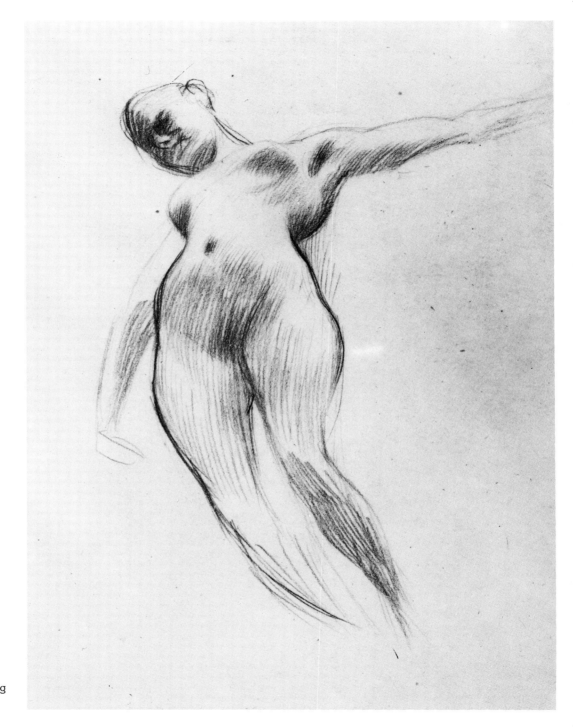

11
Girl floating in air
Schwebende
Black chalk
38.3 × 28.0
Study for the Faculty painting
Medicine (1901-7)
Vienna, Graphische
Sammlung Albertina
(Inv. 23674)

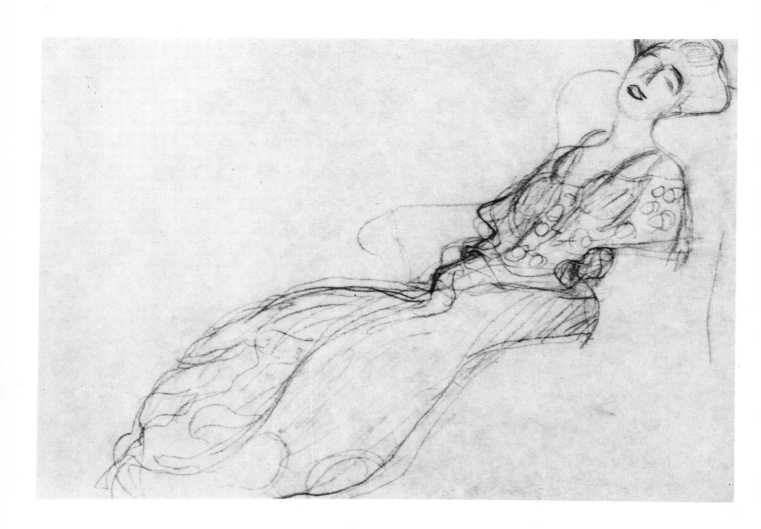

12
*Study for portrait of Adele
Bloch-Bauer*
*Studie für das Bildnis Adele
Bloch-Bauer*
Red crayon
31.0 × 45.0
One of numerous studies for
this portrait (1907)
Brussels, private collection

13
*Study for portrait of Margaret
Stonborough-Wittgenstein,*
1904-5
*Studie für das Porträt
Margaret Stonborough-
Wittgenstein*
Red crayon
55.1 × 35.2
Linz, Neue Galerie der Stadt
Linz - Wolfgang Gurlitt
Museum

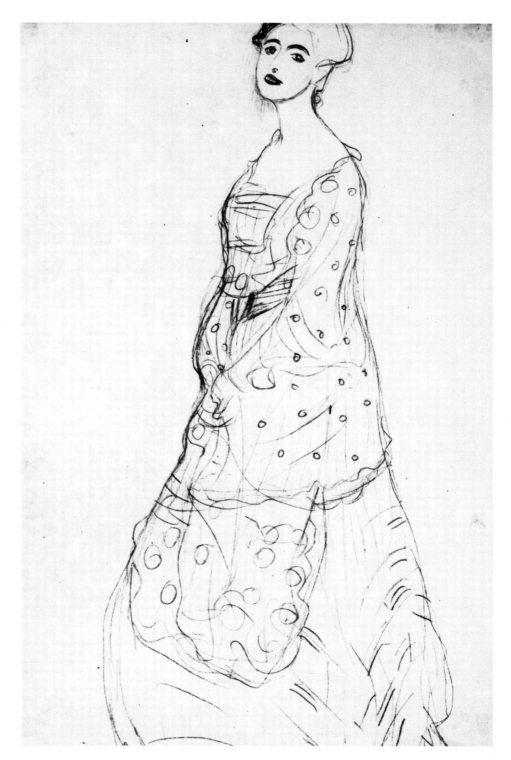

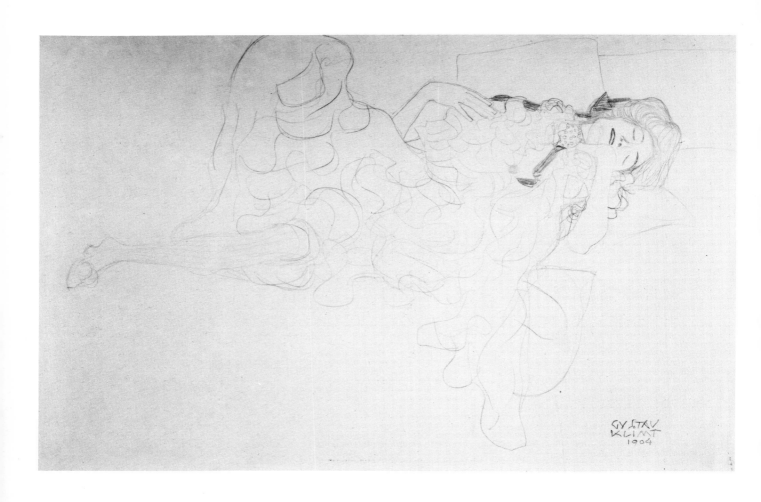

14
Reclining woman, 1904
Liegende Frau
Pencil
35.0 × 55.2
Signed and dated: *GUSTAV
KLIMT 1904*
Stuttgart, Graphische
Sammlung Staatsgalerie

46

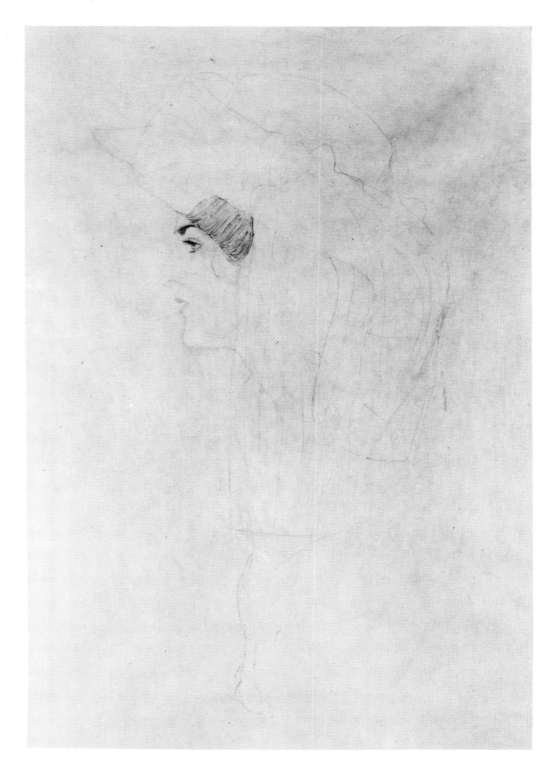

15
Woman's head with hat, 1904
Frauenkopf mit Hut
Pencil
47.7 × 32.2
Vienna, Graphische
Sammlung Albertina
(Inv. 23544)

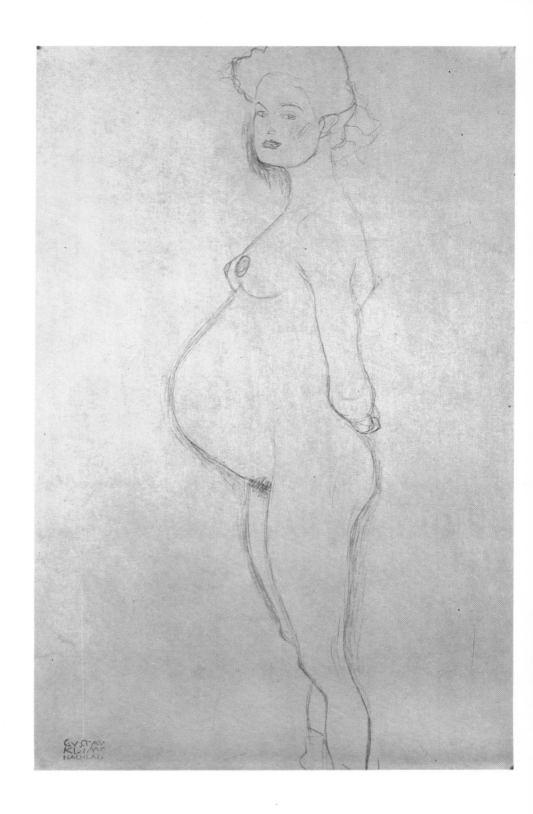

16
Nude pregnant woman
Nackte schwangere Frau
Red and blue crayon
55.9 × 37.0
Stamp of Estate
Vienna, Sammlung Dr Rudolf
Leopold

48

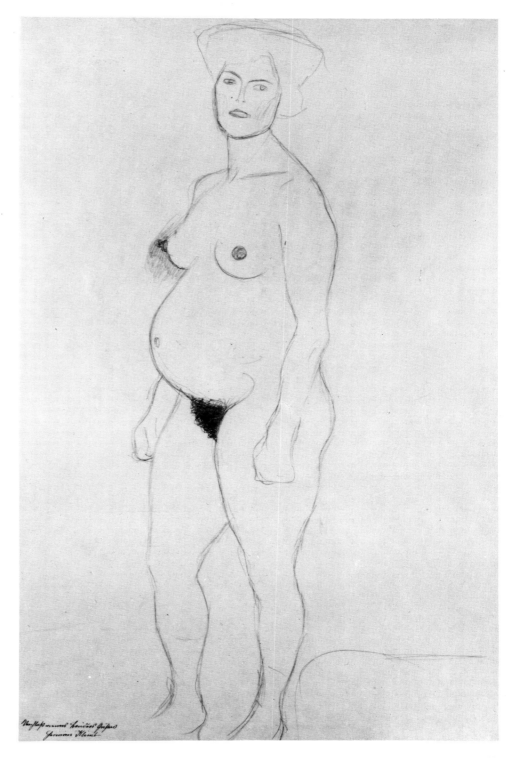

17
Nude pregnant woman
Nackte schwangere Frau
Pencil, coloured chalks
56.0 × 37.2
Inscribed: *Nachlass meines*
Bruders Gustav Hermine
Klimt [Estate of my brother
Gustav Hermine Klimt]
Vienna, Historisches Museum
der Stadt Wien
(Inv. 101059/2)

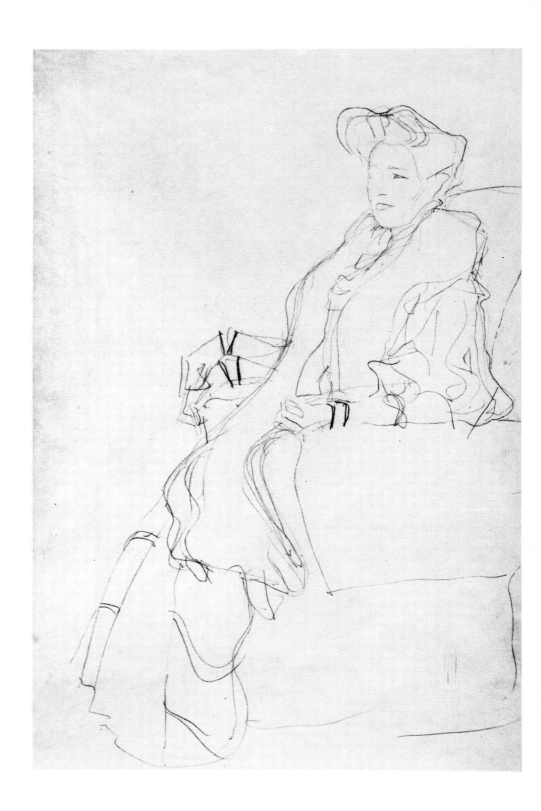

18
*Study for portrait of Fritza von
Riedler, c.* 1905
*Studie für das Bildnis Fritza
von Riedler*
Black chalk and charcoal
54.5 × 34.0
Vienna, private collection

50

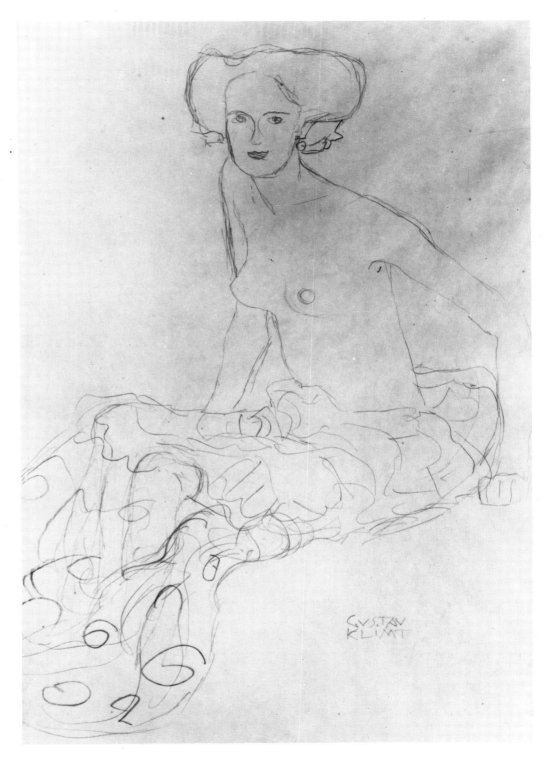

19
Seated semi-nude figure,
1907
Sitzender Halbakt
Pencil, red and blue crayon
54.7 × 36.0
Signed: *GUSTAV KLIMT*
Vienna, Graphische
Sammlung Albertina
(Inv. 29776)

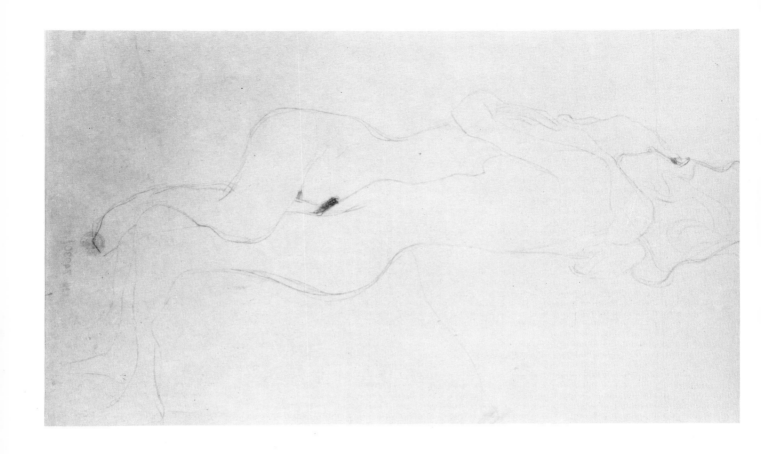

20
Lesbians
Lesbierinnen
Red chalk
35.0 × 55.1
Vienna, Historisches Museum
der Stadt Wien
(Inv. 74930/173)

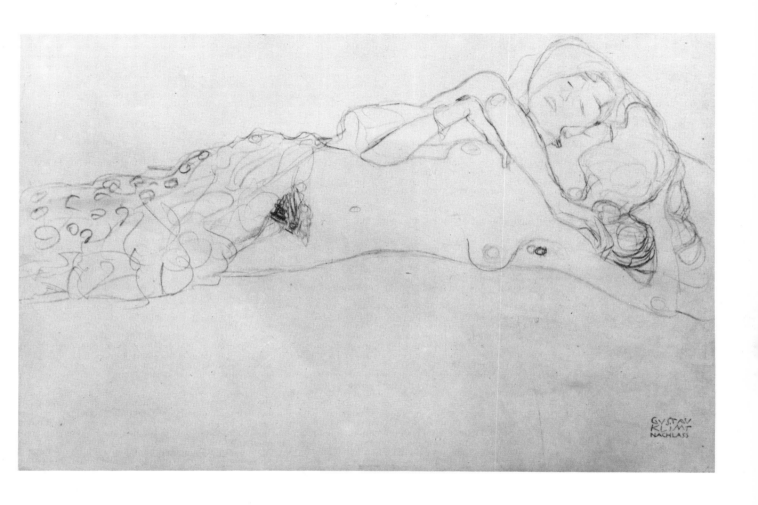

21
Two reclining women
Zwei liegende Frauen
Red chalk
36.8 × 56.0
Stamp of Estate
Graz, Neue Galerie am
Landesmuseum Joanneum
(Inv. 1728)

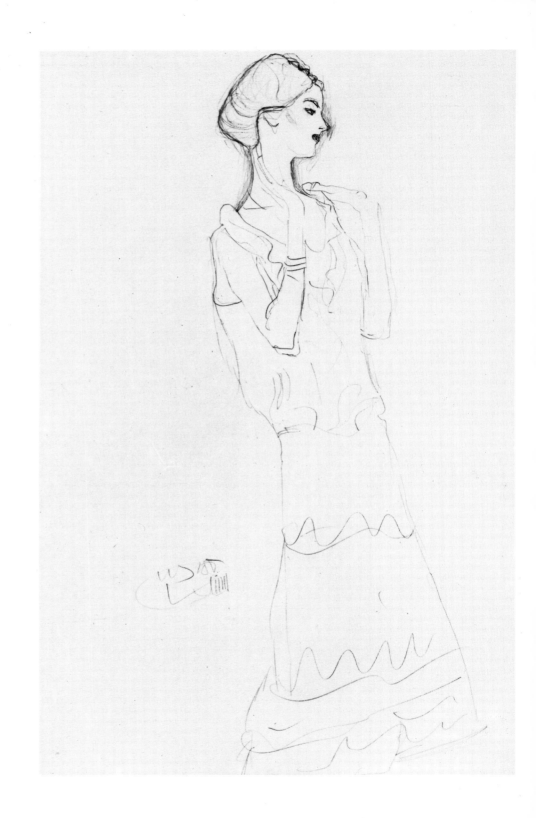

22
*Female figure with forearms
raised, 1906-7*
*Weibliche Figur mit
erhobenen Unterarmen*
Pencil and red crayon
heightened with white
55.9 × 36.8
Signed: *Gustav Klimt* (oval)
Private collection

54

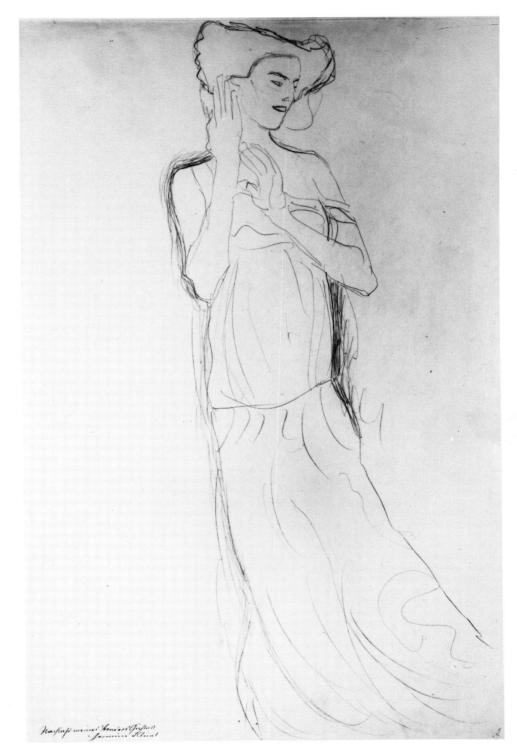

23
Expectation
Erwartung
Pencil
55.8 × 37.0
Inscribed: *Nachlass meines Bruders Gustav/Hermine Klimt* [Estate of my brother Gustav Hermine Klimt]
This and the preceding are studies for the figure of Expectation in the Stoclet mosaic, Brussels
Vienna, Historisches Museum der Stadt Wien
(Inv. 101059/8)

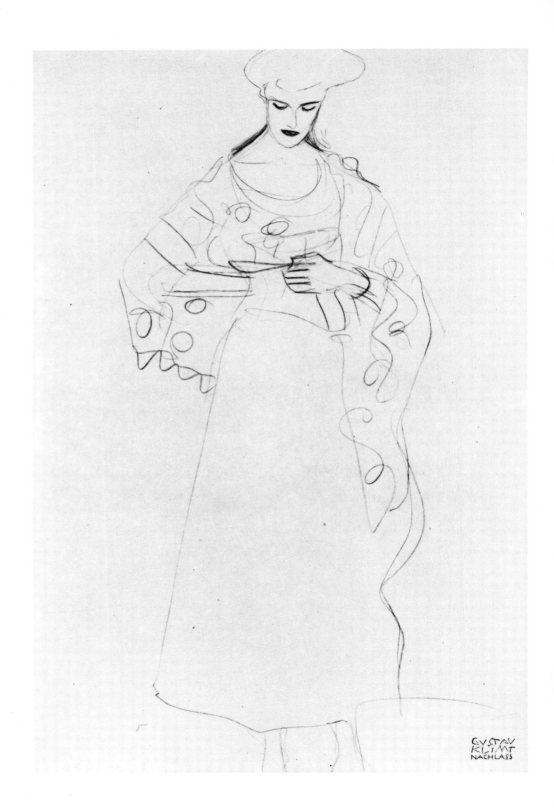

24
Girl reading, c. 1905-7
Lesendes Mädchen
Red and blue crayon
Stamp of Estate
Possibly a sketch for the
Stoclet mosaic
Private collection

56

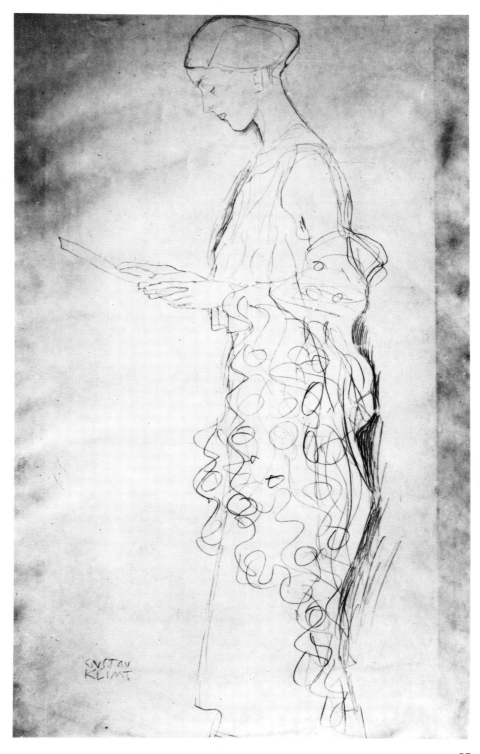

25
Girl reading, 1908
Lesendes Mädchen
Pencil
49.8 × 32.2
Signed: *GUSTAV KLIMT*
Vienna, Graphische
Sammlung Albertina
(Inv. 23541)

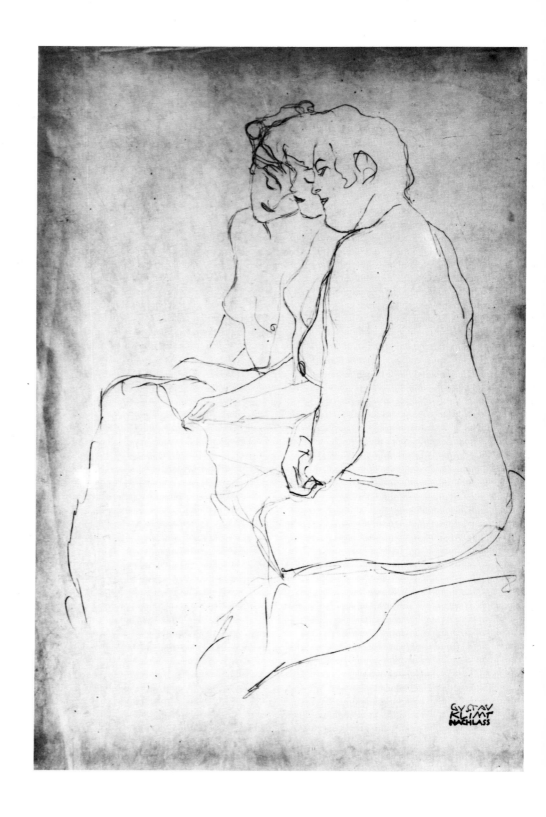

26
Three seated nudes, c. 1907
Drei sitzende Akte
Pencil
56.5 × 37.0
Stamp of Estate
Prague, Národní Galerie

27
Crouching female figure,
c. 1909
Kauernde
Pencil, chalk, grey and brown
wash
54.9 × 34.8
Study for *Mother with child*
(1910) (D. 163)
Vienna, Historisches Museum
der Stadt Wien (Inv. 101692)

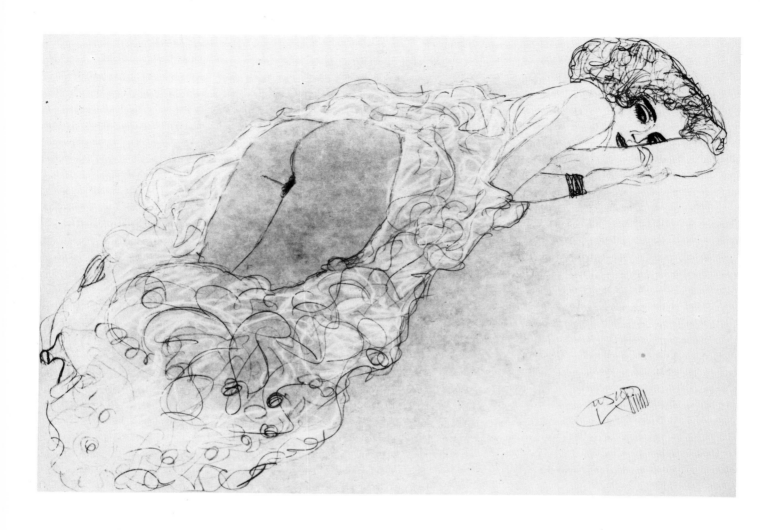

28
Figure lying on her belly,
1909-10
Auf dem Bauch Liegende
Pencil, red and blue crayon
37.0 × 56.0
Signed: *Gustav Klimt* (oval)
Private collection

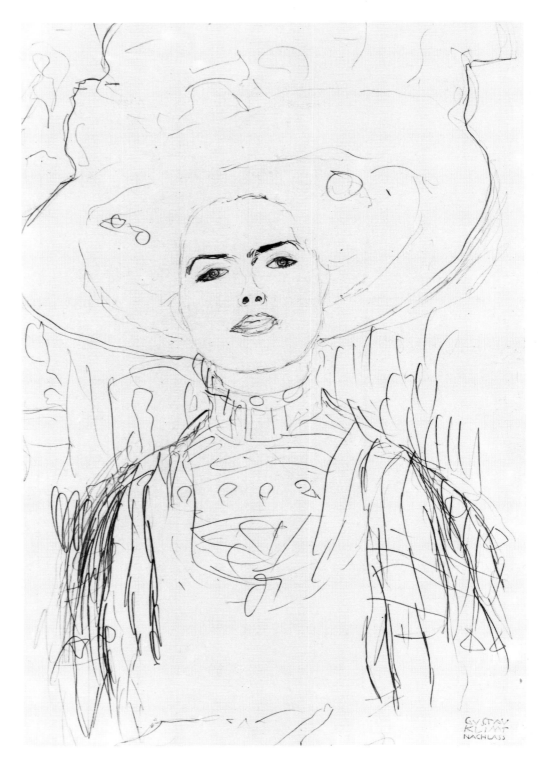

29
Half-length study of girl with
large hat, 1911
Brustbild eines Mädchens mit
grossem Hut
Pencil
55.8 × 37.2
Stamp of Estate
Private collection

30
Reclining girl, c. 1915
Liegendes Mädchen
Pencil
37.1 × 56.8
Vienna, Historisches Museum
der Stadt Wien
(Inv. 74.930/223)

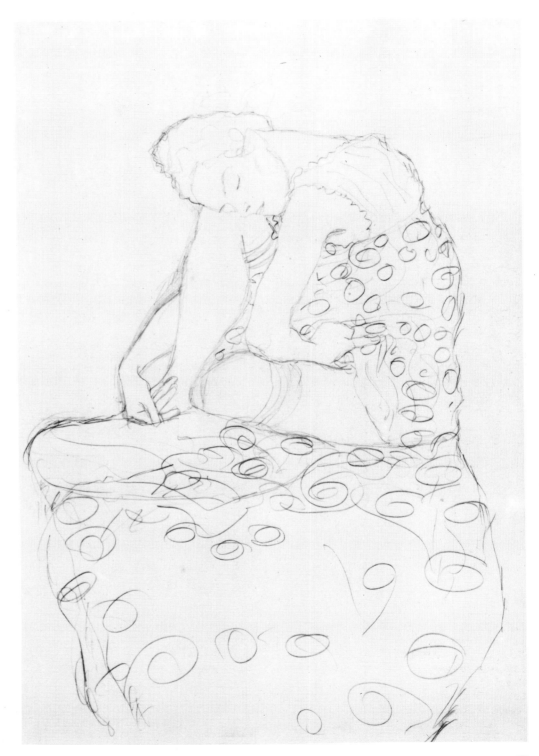

31
Study for 'Virgin', 1913
Studie zu dem Bild 'Jungfrau'
Pencil
55.2 × 36.6
Stamp of Estate (on back)
Munich, Staatliche
Graphische Sammlung
(Inv. 1958.40)

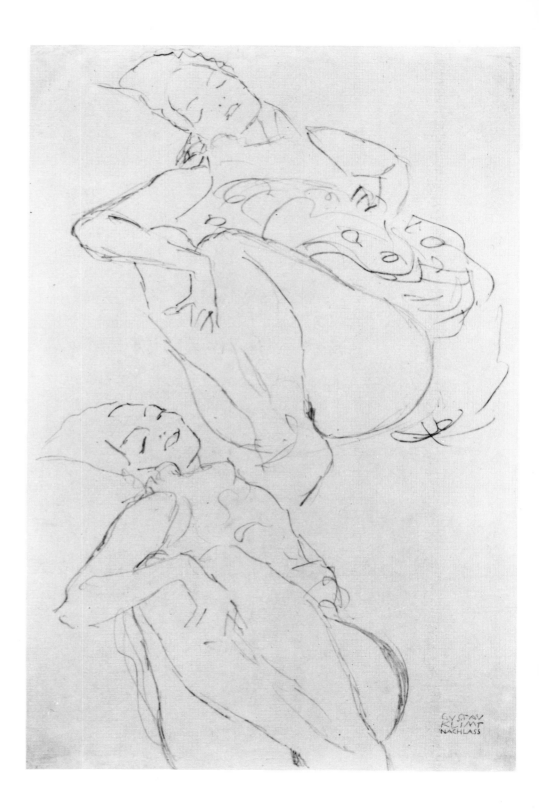

32
Two studies, 1913-15
Zwei Studien
Pencil
56.6 × 37.0
Stamp of Estate
Zurich, Graphische
Sammlung der Eidg.
Technischen Hochschule
(Inv. 1960/55)

64

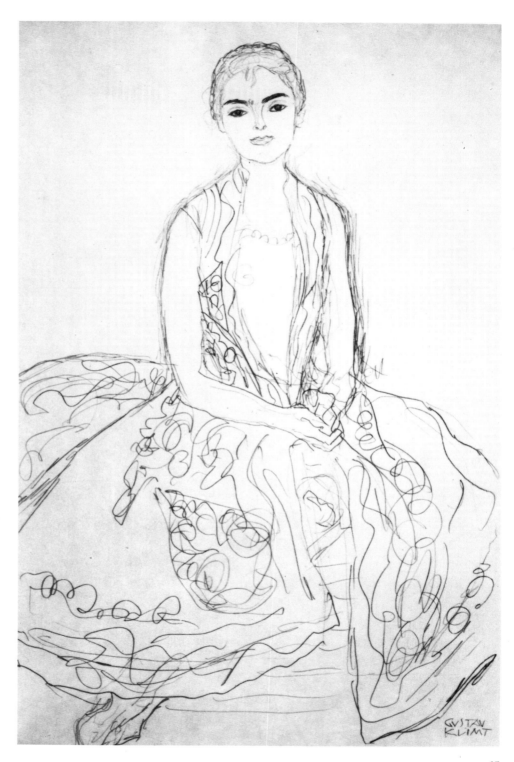

33
Seated girl, c. 1915
Sitzendes Mädchen
Pencil, red crayon,
heightened with white
50.0 × 33.2
Signed: *GUSTAV KLIMT*
Private collection

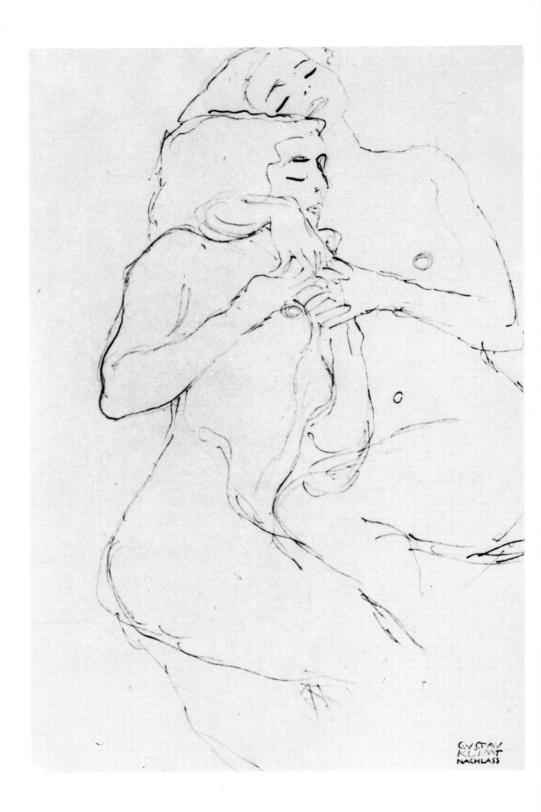

34
Two girls embracing, 1915-16
Zwei sich umarmende Mädchen
Pencil
50.0 × 36.7
Stamp of Estate
Possibly a study for *Girl Friends*
Private collection

66

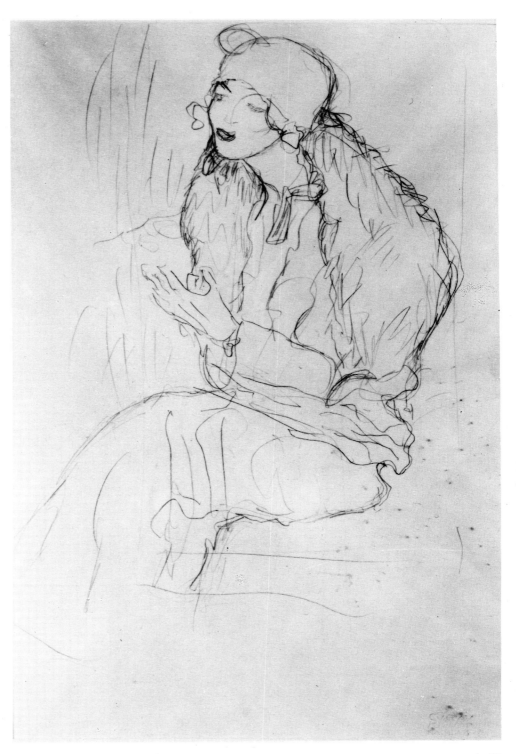

35
Portrait of a seated lady with boa
Bildnis einer sitzenden Dame mit Boa
Pencil, blue crayon, heightened with white
56.7 × 37.2
Stamp of Estate
Study for the portrait *The Fur Collar* (c. 1916)
Vienna, Graphische Sammlung Albertina
(Inv. 29544)

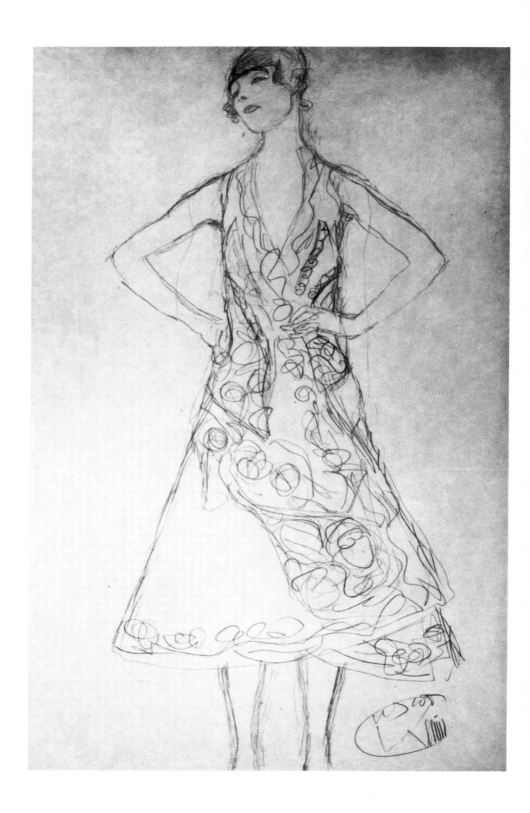

36
Lady in ornate dress, c. 1916
*Dame in reich
ornamentiertem Kleid*
Pencil, red crayon,
heightened with white
50.0 × 32.3
Signed: *Gustav Klimt* (oval)
The face resembles that in the
Dancer of 1916-18 (D. 208)
Graz, private collection

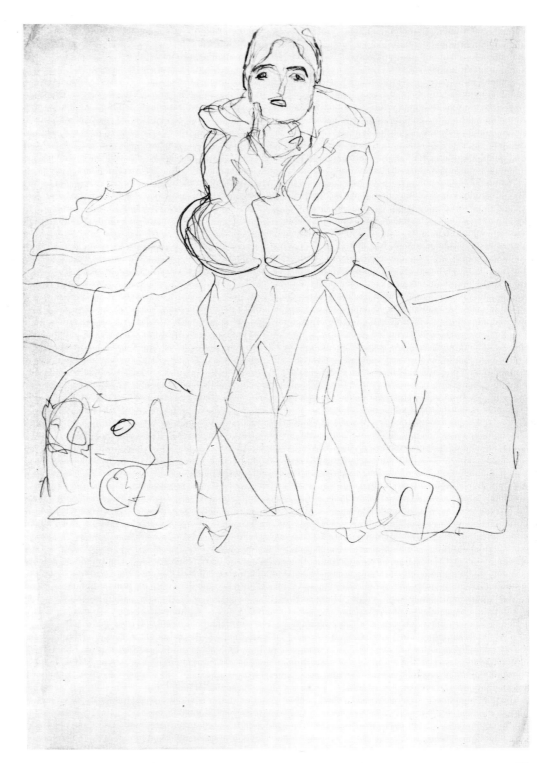

37
Study for portrait of Frederike
Beer-Monti, 1916
Studie zum Porträt Frederike
Beer-Monti
Pencil
56.0 × 37.0
Vienna, private collection

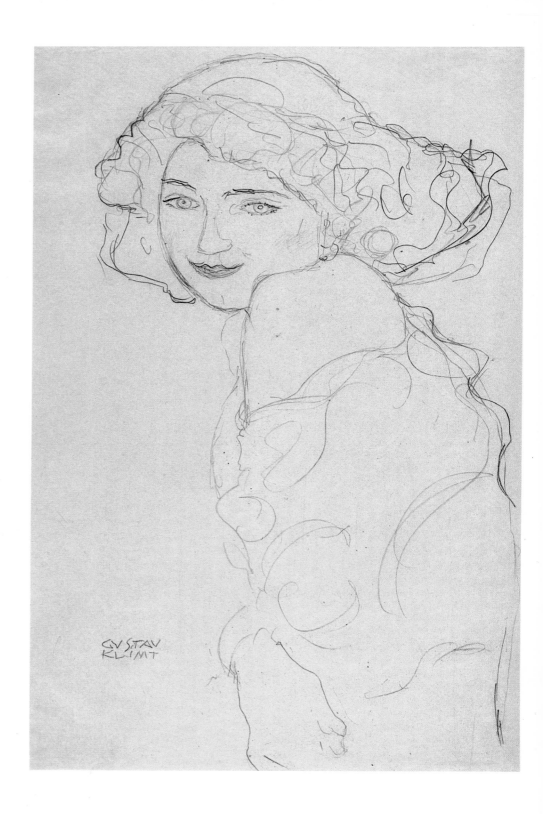

38
Portrait of a girl, c. 1916
Mädchenbildnis
Pencil, red and blue crayon,
heightened with white
56.5 × 37.5
Signed: *GUSTAV KLIMT*
Berne, Sammlung E.W.
Kornfeld

70

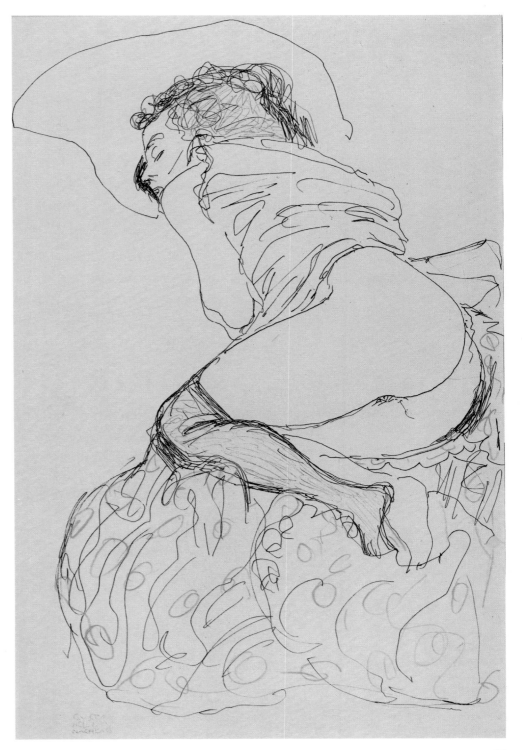

39
Reclining semi-nude figure,
c. 1917
Liegender Halbakt
Pencil, pen, india ink, red
crayon
56.5 × 37.2
Stamp of Estate
Vienna, private collection

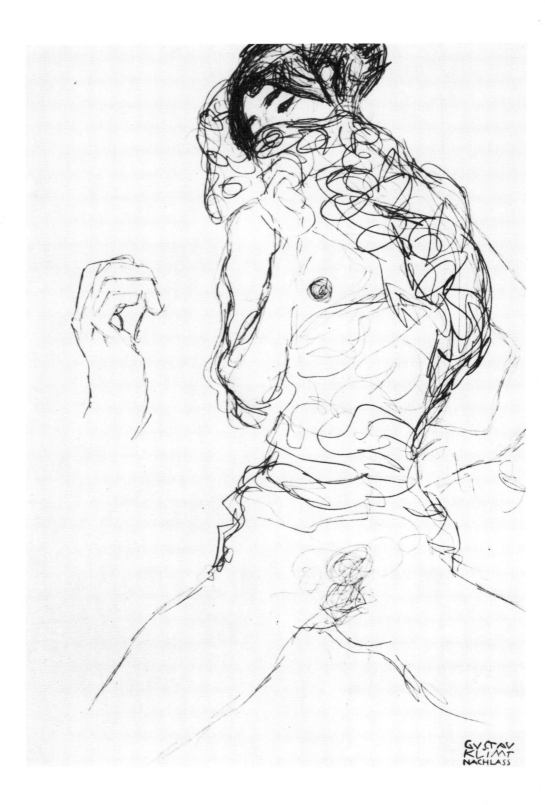

40
*Semi-nude figure with partly
covered face; sketch of the
right hand*
*Halbakt mit teilweise
verdecktem Gesicht; Skizze
der rechten Hand*
Pencil
50.1 × 32.5
Stamp of estate
Study for the figure on the
right-hand side of *The Bride*
(1917-18)
Private collection

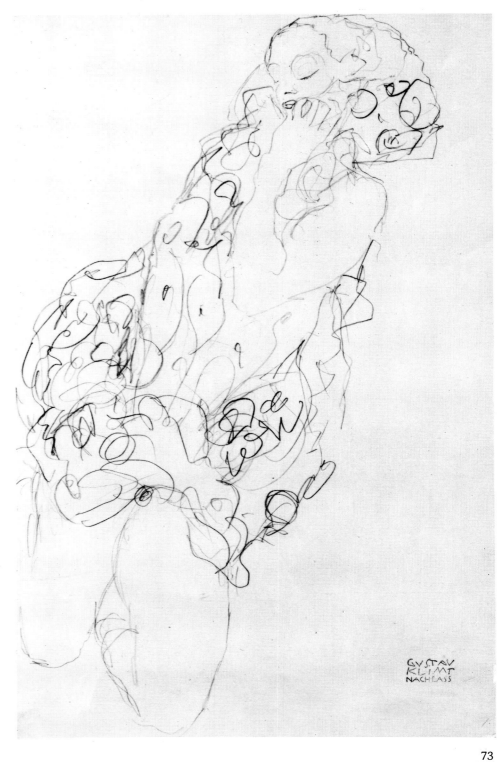

41
Sleeping girl
Schlafendes Mädchen
Pencil
49.8 × 32.2
Stamp of Estate
London, Sammlung
Dr Wolfgang Fischer

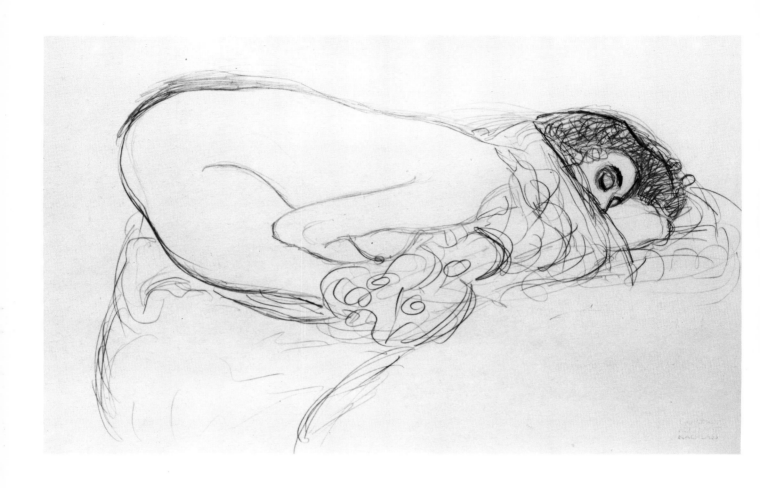

42
Danaë
Danaë
Pencil
36.7 × 55.9
Stamp of Estate
Vienna, Sammlung Dr Rudolf
Leopold

74

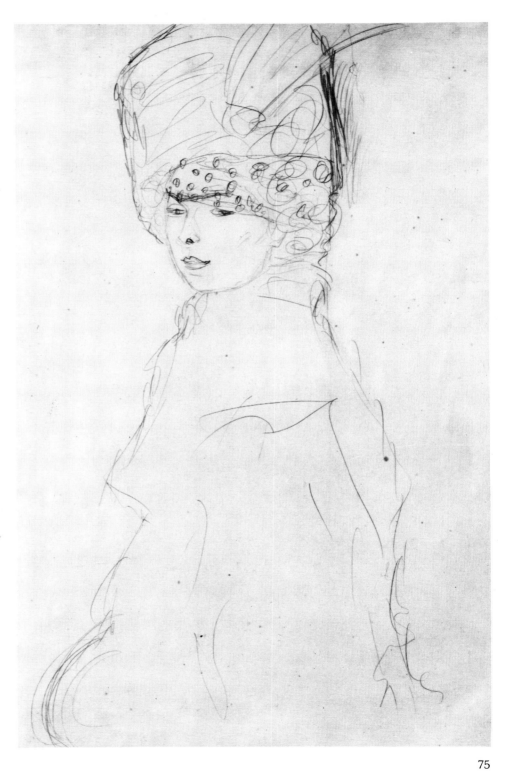

43
Girl with feathered hat
Mädchen mit Federhut
Pencil
55.0 × 35.6
Private collection
Courtesy Fischer Fine Art,
London

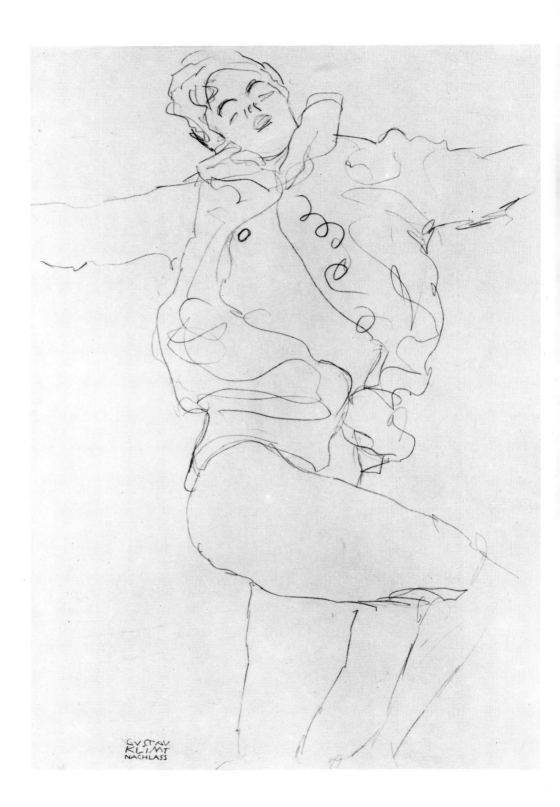

44
Bacchante
Bacchantin
Pencil
56.9 × 37.3
Stamp of Estate
Vienna, Sammlung Dr Rudolf
Leopold

76

EGON SCHIELE

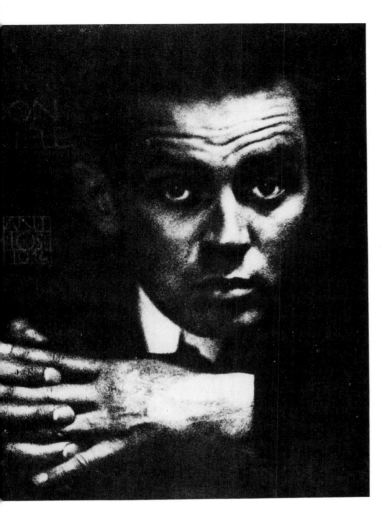

Egon Schiele was born in a middle-class family on 12 June 1890. His paternal grandfather was a railway engineer of genius, his father a station-master, who became paralysed in 1902 and died in 1905, leaving his family badly off. Egon went to the Vienna Academy at sixteen and received three years of thorough, old-fashioned tuition in drawing there (1906-9). Artist friends in Klosterneuburg encouraged him to take up painting even before he entered the Academy. His evolution into an Expressionist took place in the course of a few months in 1909. His creative career lasted only another nine years, cut short by his death in 1918. A small circle of collectors soon recognized his talent and regularly bought his work. The majority of his paintings were male portraits, landscapes or allegories. He made his living with his drawings, all of them signed and dated and properly finished works of art. Like Klimt, he was one of the best draughtsmen of the time. How many of his drawings have survived is uncertain, but there must be several thousands. In 1911 he and his girl-friend Wally Neuziel were told to leave Krumlov (his mother's home town); the inhabitants seem to have been offended by their ménage. In 1912 he was held in prison for three weeks in Neulengbach, while charges of immoral behaviour with an under-age girl were investigated. The charges were dropped, but he was sentenced to three days' imprisonment for not keeping an erotic nude drawing under lock and key. Just before being conscripted in 1915 he married Edith Harms and thus was drawn back into the petty bourgeois milieu that he had thought he had left for good in 1910, after quarrelling with his uncle and guardian. Contemporary critics rejected him and, like Klimt, he failed to win recognition outside Austria. He gave lessons to a few amateur painters but, like Klimt, had no pupils.

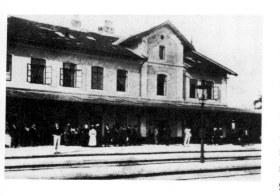

The railway station at Tulln, west of Vienna, where Schiele's father was station-master. Schiele was born in the last room on the extreme right, on the first floor. All through his life he was fascinated by the railway, and many of his relatives and connections were in railway employ (his uncle, who was also one of his guardians, his sister Melanie, his paternal friend Heinrich Benesch, his father-in-law etc.). As a child he drew nothing but locomotives and trains and seems to have been adept at imitating all their noises. As the son of a railwayman he was entitled to free travel: he often got on to a train in the evening, travelled around all night, to return home only in the morning.

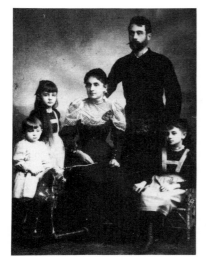

The Schiele family, about 1892. Adolf and Marie Schiele (*née* Soukup), with Egon on a rocking horse, left, Elvira, who died young, and Melanie, right. Egon seems to have inherited some malady from his father. Outwardly he was cheerful and carefree, but his pictures reveal inner tensions: there is never a smiling face, he painted scenes of autumn and winter, and often death. 'I am human, I love death and I love life' (probably written 1910). There is a parallel to Edvard Munch, who lost his mother and two beloved sisters in childhood. This is probably the reason for his frequent depictions of fear and death.

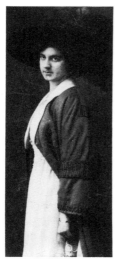

Melanie Schiele, about 1908. Schiele's elder sister worked for the railways. When young she often had her photograph taken, wearing hats she had made herself. In that she resembled her brother, who was a true Narcissus and drew and painted himself hundreds of times — brooding, scowling, sad, never happy and relaxed.

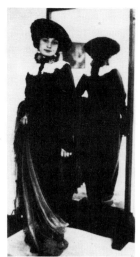

Schiele's younger sister Gertrude (Gerti), born 1894, played a more important part in his life. From a playmate, he developed into a strange relationship with her: at first authoritarian, then inquisitive, admiring, protective and jealous. That he drew her in the nude several times, when she was barely out of puberty, is remarkable by any standards. The portrait of her painted in 1909 is a key work in his development of Expressionist style. He found her a job as mannequin at the Wiener Werkstätte, and she is seen here in a dress for the Werkstätte in front of the large mirror in his studio (1911-12). In 1914 she married one of his friends, the painter Anton Peschka.

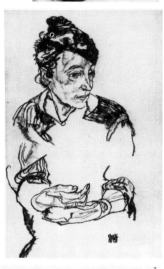

Marie Schiele, *née* Soukup (1862-1935), from a drawing by her son, 1918. She sent Egon to the Academy, in spite of the opposition of his other guardian, his uncle, but the relationship of mother and son was not a good one, and she lacked sympathy or understanding for him. From 1910 he lived his own life. She pestered him with requests for money. 'Dear Mother Schiele, what's the use of all these letters, which only end up on the fire. If you need anything, come and see me, I shall never go home again. Cordially, Egon.' (1913)

Not only was Schiele's handwriting beautiful (the reason, apparently, why the army was reluctant to have him moved from a clerkship), but he was also communicative. He normally used German cursive script, but occasionally, as here, he wrote in capital letters. This, one of his most beautiful letters, written in the hope of settling a dispute, was addressed to the Viennese art critic Arthur Roessler, one of his patrons and champions. Schiele was proud and self-confident. In December 1910 he wrote to Roessler, about a painting that no longer exists, 'I want to know who gets my picture *The Self-seers*, perhaps I won't let them have it. I'm not giving my works to just anybody.' Schiele wrote a series of Expressionist poems in 1910, which have not yet received sufficient attention.

Schiele posing like a dancer beside his lost picture *The Encounter*, 1913. This photograph is one of a whole series taken of him by other painters at the time of his discovery of the artistic potential of photography. The painting was not finished, but he entered it for the international Carl Reininghaus Competition in 1914. Although it did not get an award Reininghaus, one of the principal collectors of modern art in Vienna, bought it after the exhibition. Among the other competitors were Marie Laurencin and Raoul Dufy.

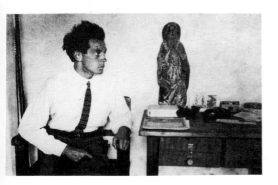

Schiele in his studio, around 1916. The chair on which he sits appears in some of his portraits, and the figure on the table was in his own collection. He became a collector as soon as his finances began to improve. He had a great success in the sale of his work at the 49th Secession exhibition in the spring of 1918, and shortly afterwards the Österreichische Galerie acquired the portrait of his wife Edith (née Harms; they married in June 1915, just before his conscription). Schiele died three days after his wife (who was in the sixth month of pregnancy) on 31 October 1918, at the age of twenty-eight. Both were victims of the Spanish influenza epidemic which claimed more lives than the First World War. Schiele's last words are alleged to have been: 'The war's over — and I must go. My paintings must be shown in every museum in the world.'

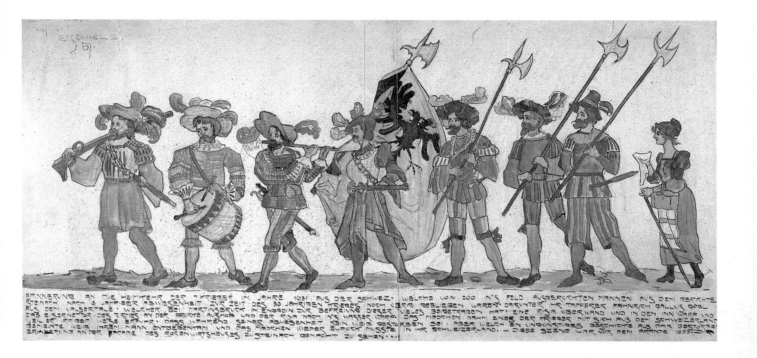

45

*Commemoration of the return
of the seven warriors 1631
Erinnerung an die Heimkehr
der sieben Krieger 1631*
India ink and watercolour
38.2 × 79.8
Signed and dated:
E. SCHIELE 07
Vienna, Sammlung
Ing. Norbert Gradisch

The picture, which was copied by Schiele, portrays the homecoming from Switzerland of the seven warriors in 1631; they were all that remained of the two hundred who had set out from the Steinach district three years before. The girl was brought back by one of the men, who had heard, mistakenly, that in his absence his wife had died. When the supposedly dead wife came out to meet her husband, the girl had to return to Switzerland. The scene was commemorated in a painting on the façade of the Rose Inn at Steinach until the fire of 1853.

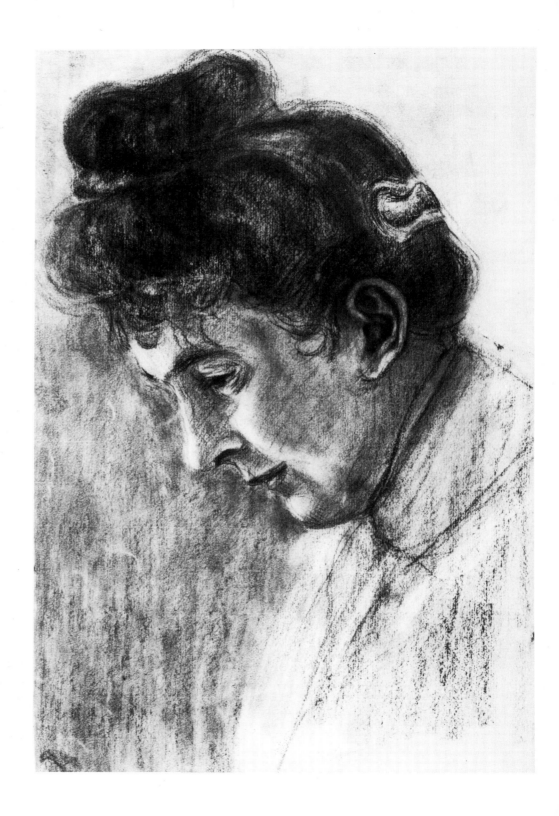

46
*Marie Schiele, the artist's
mother,* 1906
*Marie Schiele, die Mutter des
Künstlers*
Coloured chalks
47.3 × 31.6
Dated: *24.9.1906*
Vienna, Sammlung Ing.
Norbert Gradisch

82

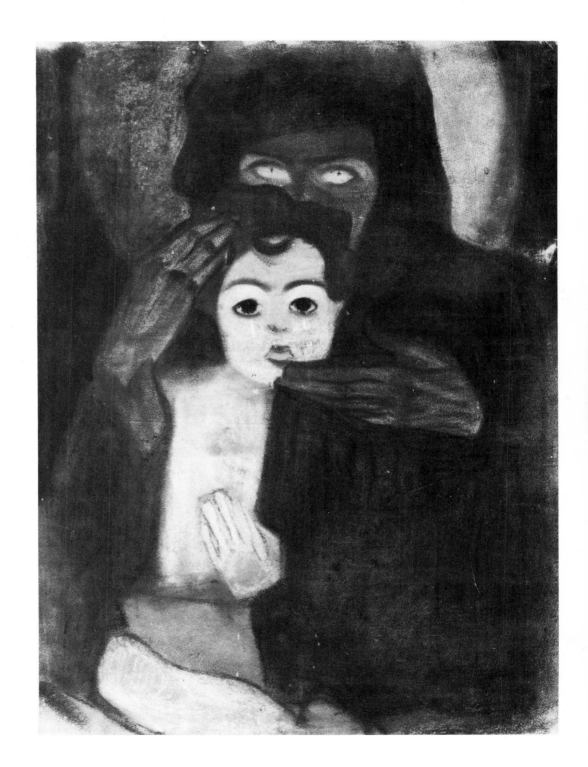

47
Mother and child, 1908
Mutter und Kind
Sanguine, white and black
chalks
60.0 × 43.5
Vienna, Niederöster-
reichisches Landesmuseum
(Inv. 1905 N 46)

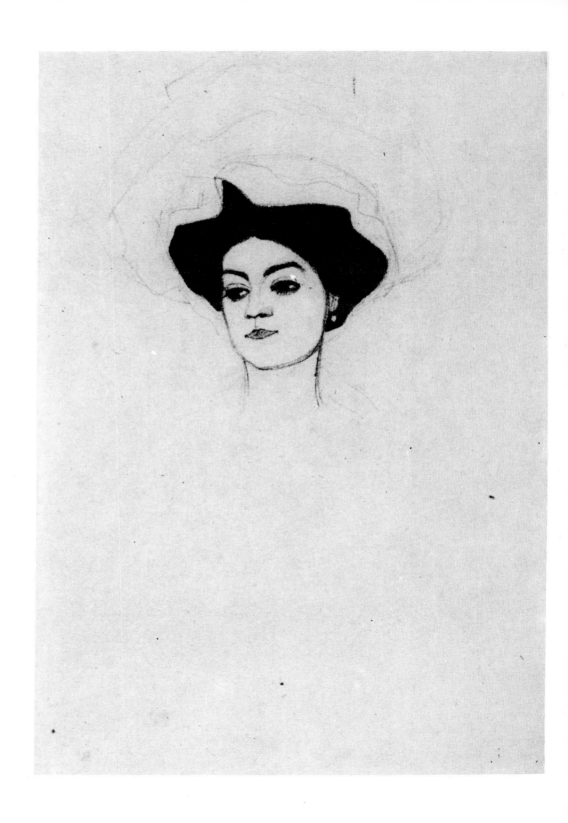

48
Melanie Schiele, 1909
Pencil
31.3 × 22.2
Stamp of Estate
Vienna, Sammlung
Ing. Norbert Gradisch

84

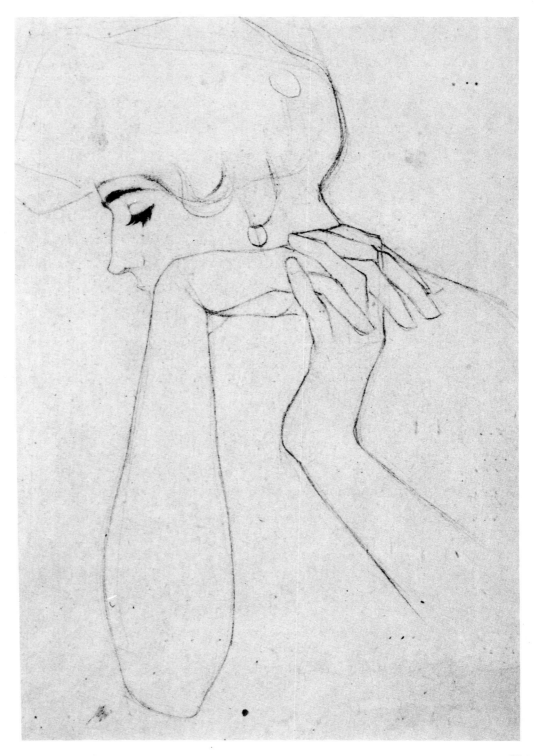

49
Melanie Schiele, 1909
Pencil
30.7 × 21.9
Stamp of Estate
Vienna, Sammlung
Ing. Norbert Gradisch

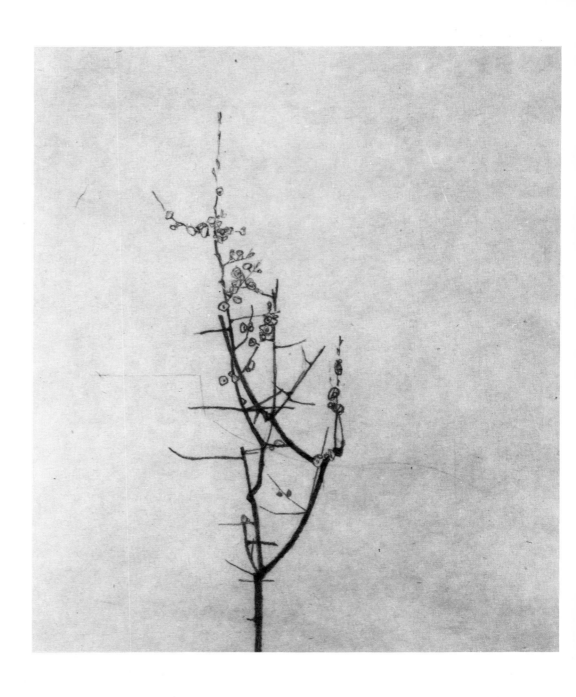

50
Tree in Blossom, 1909
Baum in Blüte
29.8 × 27.3
Private collection

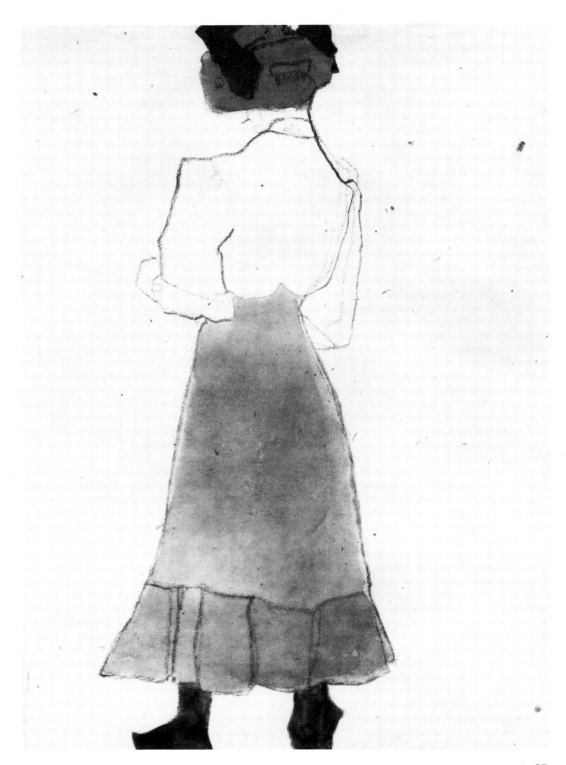

51
Woman in red skirt, c. 1909
Frau mit rotem Rock
Pencil and bodycolour
44.9 × 31.6
Vienna, Historisches Museum
der Stadt Wien

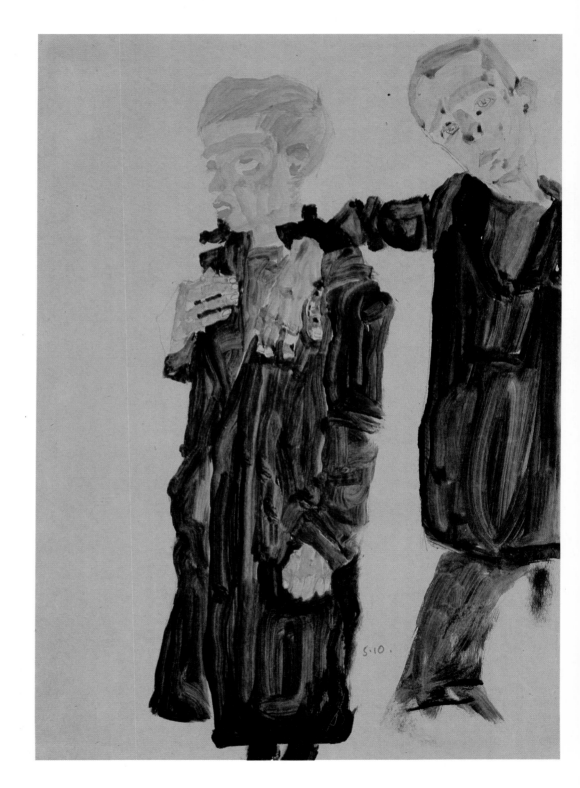

52
Two Street Urchins, 1910
Zwei Gassenbuben
Pencil, watercolour and
bodycolour
36.7 × 31.5
Monogrammed and dated:
S.10
London, Fischer Fine Art

88

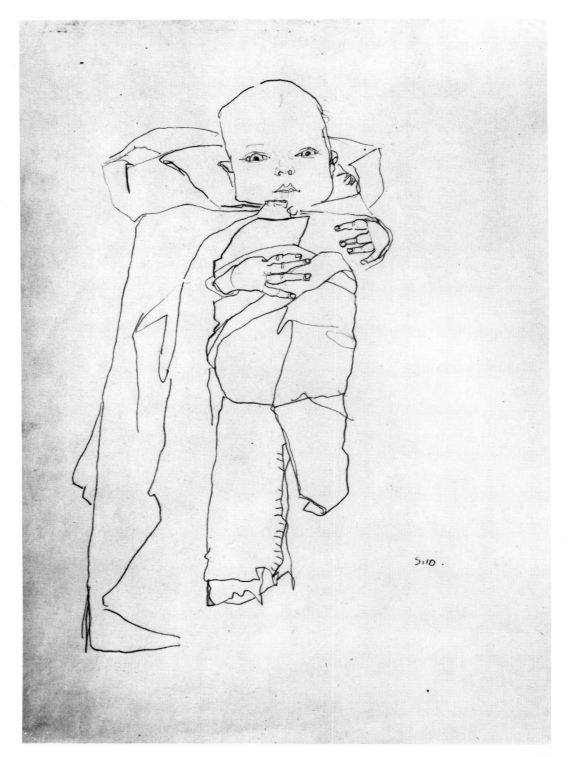

53
*Infant, swaddled, on a
cushion,* 1910
Wickelkind im Kissen
Pencil
45.0 × 32.0
Monogrammed and dated:
S.10
Graz, Neue Galerie am
Landesmuseum Joanneum
(Inv. II/10.808)

89

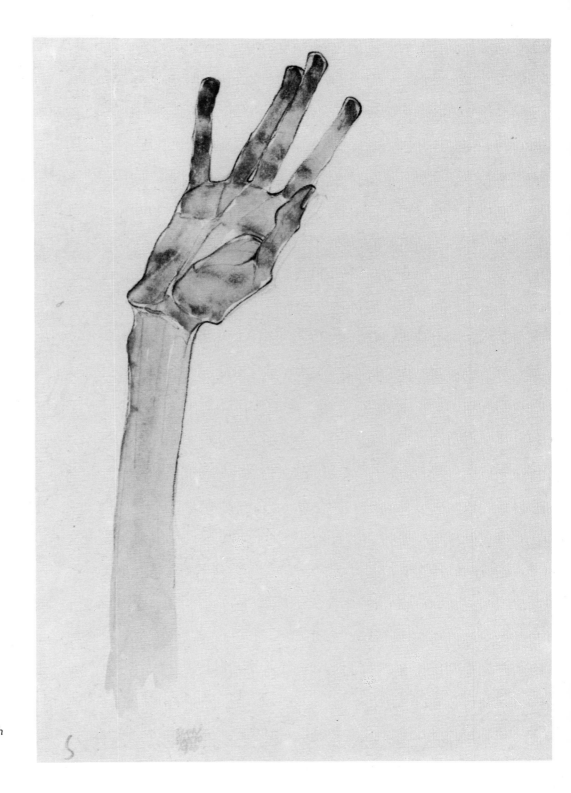

54
Study of a hand, 1910
Handstudie
Black chalk and watercolour
45.4 × 31.9
Signed and dated:
EGON/SCHIELE/1910
Sketch for *Kneeling nude with
raised hand* (self-portrait)
Private collection

90

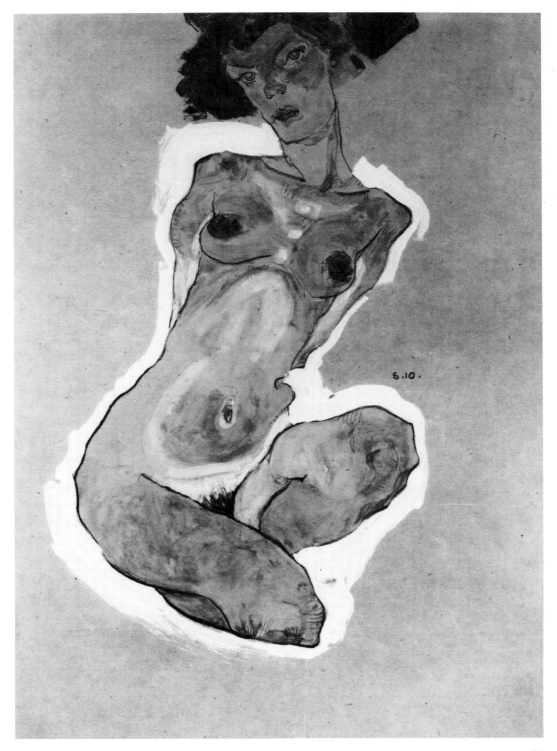

55
Squatting female nude, 1910
Kauernder Frauenakt
Black chalk, gouache and
bodycolour
44.3 × 31.0
Monogrammed and dated:
S.10
Vienna, Sammlung Dr Rudolf
Leopold

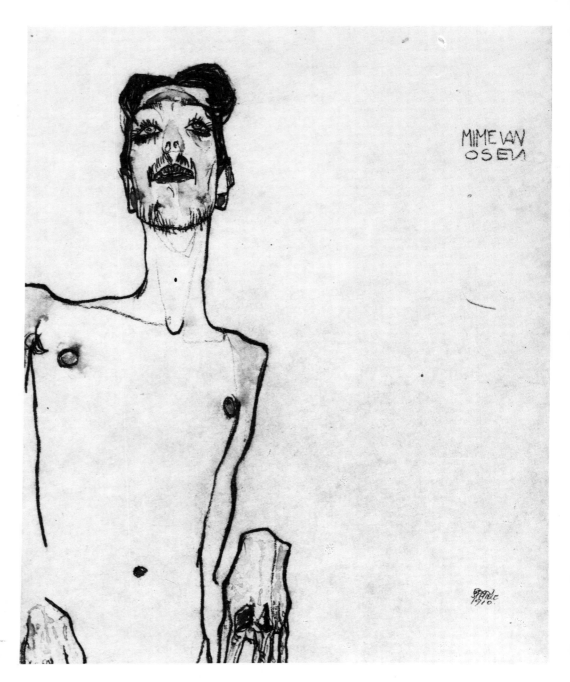

MIME VAN
OSEN

56
Mime van Osen, 1910
Black chalk and watercolour,
1910
37.8 × 29.7
Signed and dated:
EGON/SCHIELE/1910
Inscribed: *MIME VAN OSEN*
Erwin van Osen, whom
Schiele here calls Mime van
Osen, studied at the
Akademie with Schiele. He
became a scene-painter and
remained a friend of Schiele's.

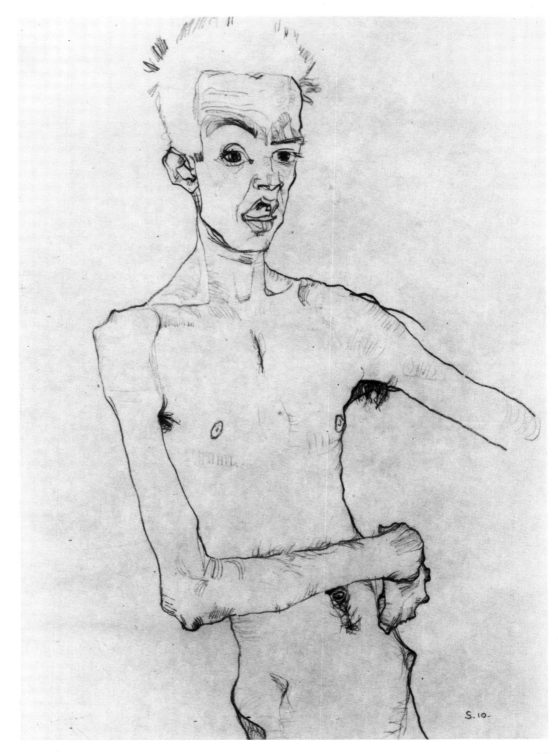

57
Self-portrait, 1910
Selbstporträt
Black chalk
45.5 × 31.4
Monogrammed and dated:
S.10
New York, courtesy of Serge
Sabarsky Gallery

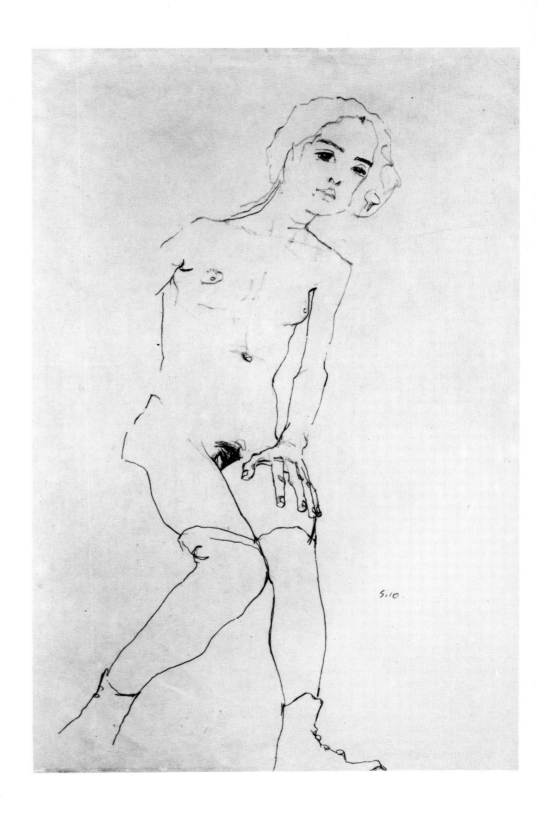

58
Seated nude girl, 1910
Sitzendes nacktes Mädchen
Pencil
55.8 × 36.8
Monogrammed and dated:
S.10
Vienna, Sammlung Dr Rudolf
Leopold

94

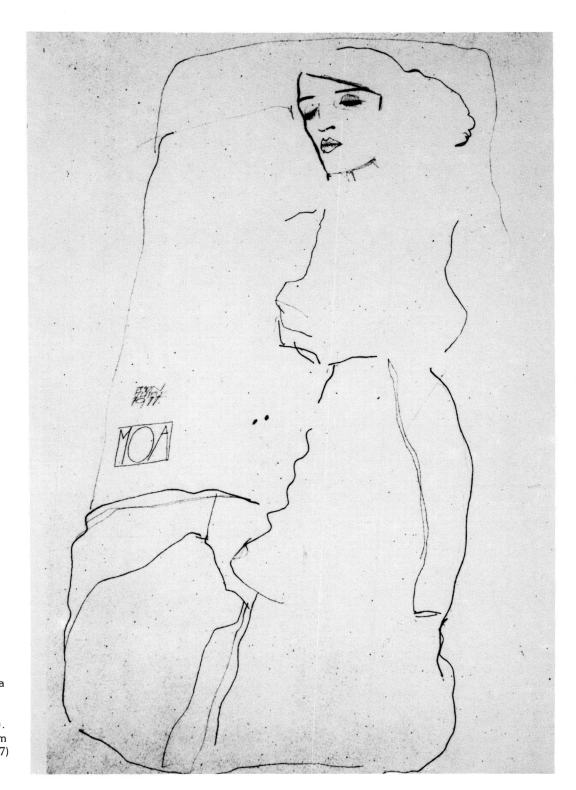

59
The dancer Moa, 1911
Die Tänzerin Moa
Pencil
48.2 × 31.9
Signed and dated:
EGON/SCHIELE/1911
Inscribed: *MOA*. The
inscription shows that this is a
portrait of the dancer Moa
(Nuhuimur?), girlfriend of
Erwin van Osen (see no. 56).
Vienna, Historisches Museum
der Stadt Wien (Inv. 115.147)

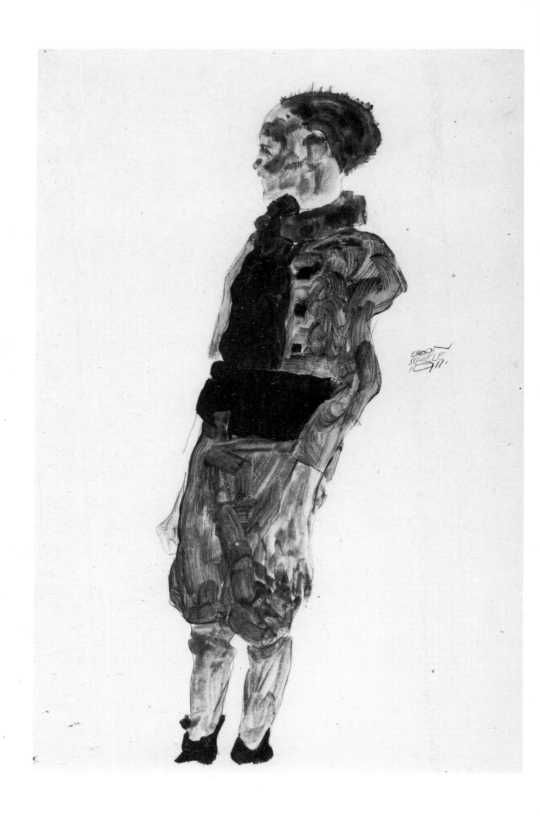

60
Standing youth, 1911
Stehender Jüngling
Watercolour
47.8 × 31.5
Signed and dated:
EGON/SCHIELE/1911
Berne, Sammlung
E.W. Kornfeld

96

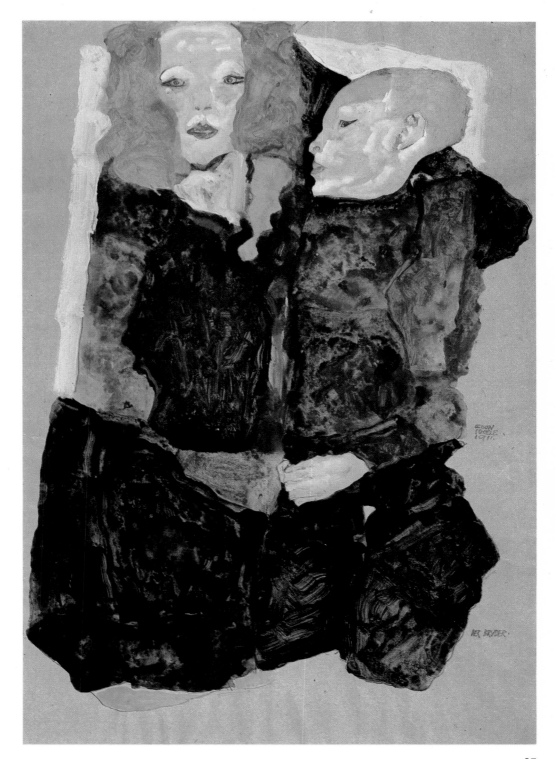

61
The brother, 1911
Der Bruder
Pencil, black chalk,
watercolour, bodycolour
44.8 × 31.0
Signed and dated:
EGON/SCHIELE/1911
Inscribed: *DER BRUDER*
Private collection

62
'The door into the open',
1912
'Die Tür in das Offene'
Pencil and watercolour
48.2 × 32.0
Signed and dated:
EGON SCHIELE 21.IV.12
G[efängnis]
One of the drawings Schiele
did in prison at Neulengbach.
Vienna, Graphische
Sammlung Albertina
(Inv. 31160)

98

63
Fence at Knappenberg, 1912
Knappenberg Zaun
Pencil and watercolour
48.0 × 31.7
London, Fischer Fine Art

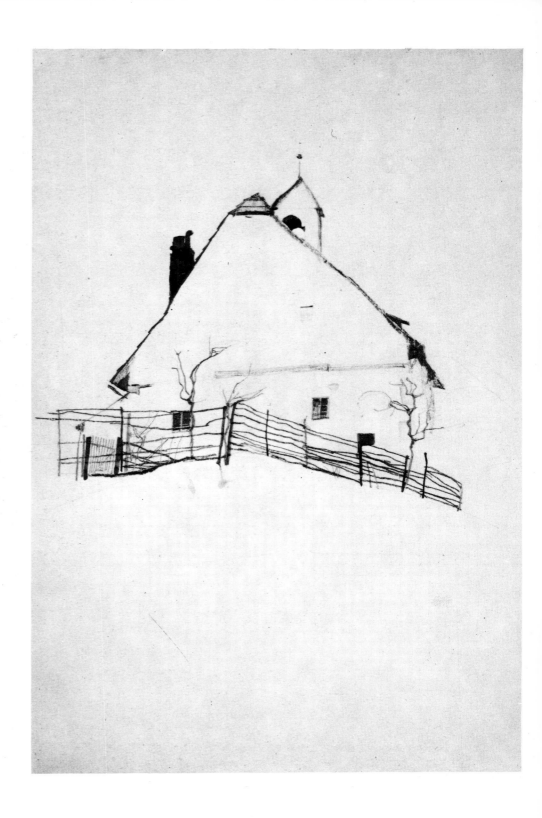

64
House with belfry on the
Semmering Pass, 1912
Glockenhaus am Semmering
Pencil and watercolour
48.0 × 32.0
London, Fischer Fine Art

100

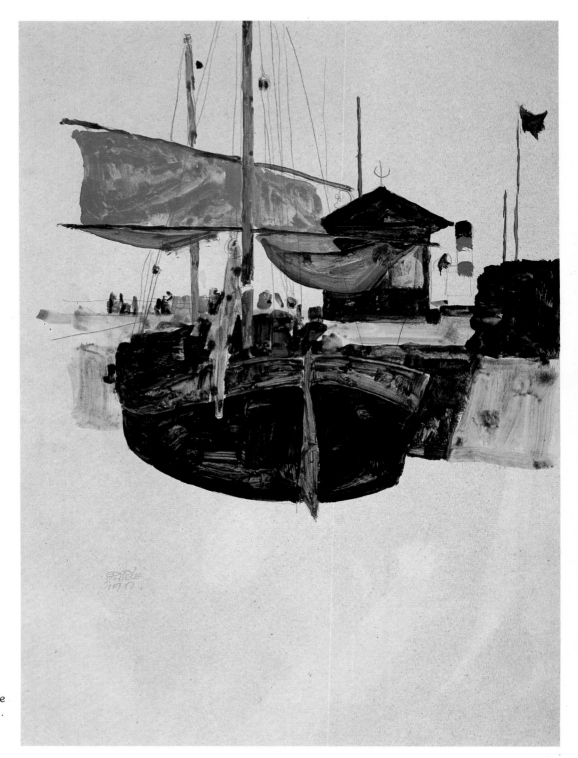

65
Boats in Trieste, 1912
Schiffe in Triest
Pencil, watercolour and
bodycolour
44.0 × 31.5
Signed and dated:
EGON/SCHIELE/1912
Drawn in Trieste, where
Schiele went after his release
from prison at Neulengbach.
Private collection (bought
from Schiele's studio)

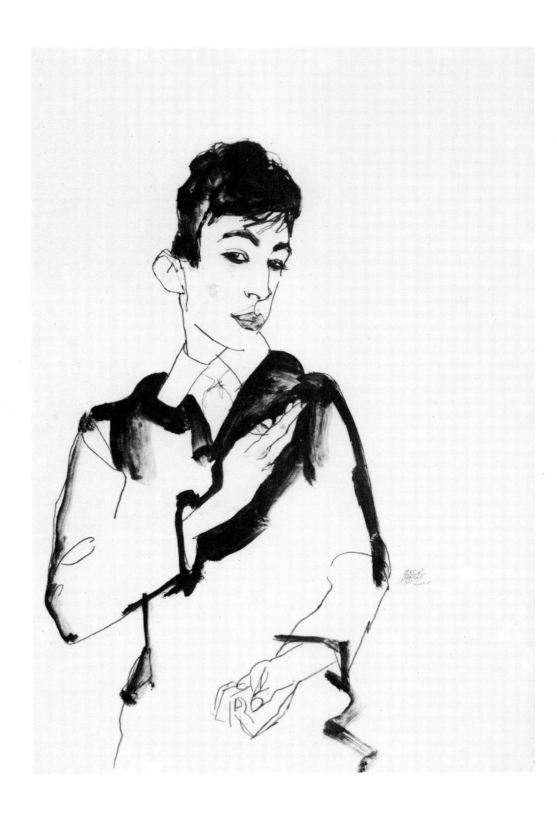

66
Portrait study E.L., 1912
Porträtstudie E.L.
Pencil and watercolour
48.1 × 31.9
Signed and dated:
EGON/SCHIELE/1912
Munich, Staatliche
Graphische Sammlung

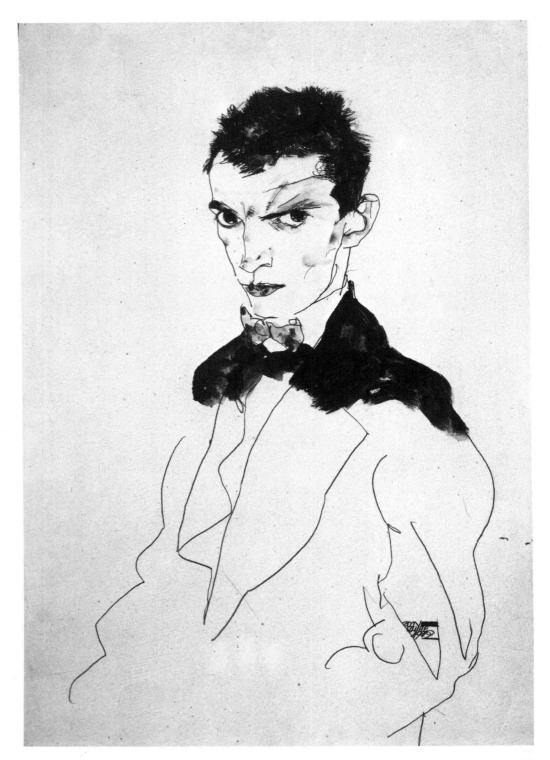

67
Self-portrait, 1912
Selbstbildnis
Pencil, watercolour and
bodycolour
46.5 × 31.7
Signed and dated:
EGON/SCHIELE/1912
Private collection

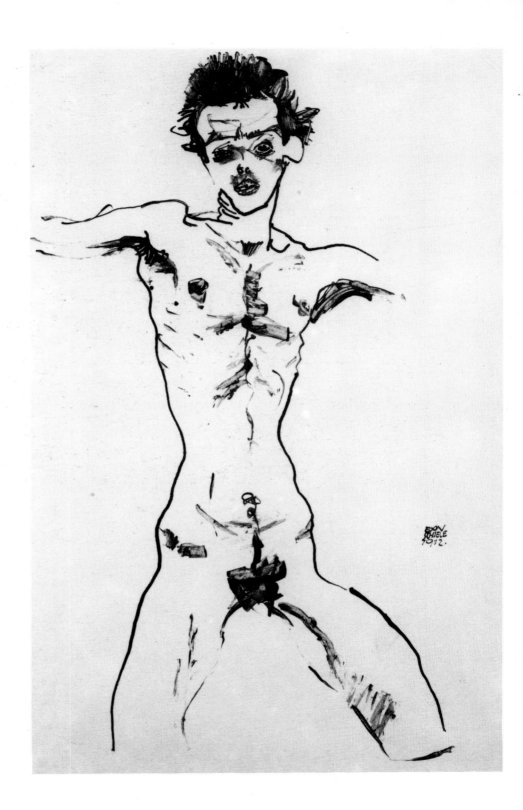

68
Nude self-portrait, 1912
Selbstdarstellung als Akt
India ink
46.7 × 30.0
Signed and dated:
EGON/SCHIELE/1912
Vienna, Sammlung Dr Rudolf
Leopold

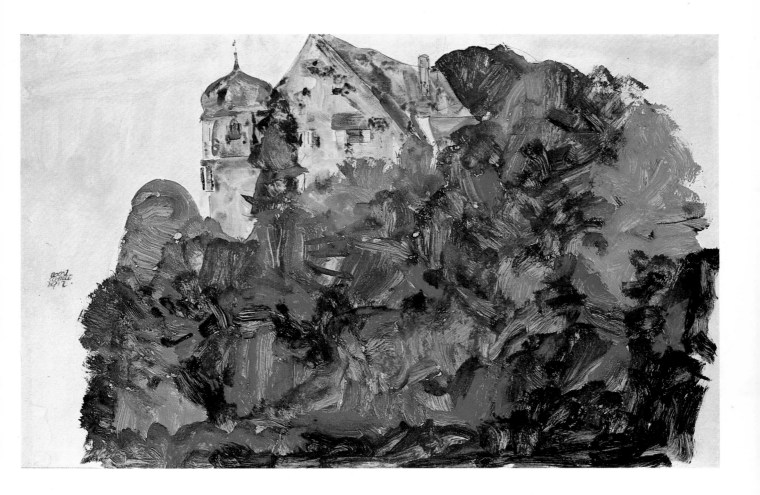

69
The little castle of Deuring,
Bregenz, 1912
Deuring-Sclösschen, Bregenz
Pencil and bodycolour
31.3 × 48.0
Signed and dated:
EGON/SCHIELE/1912
Vienna, Sammlung Dr Rudolf
Leopold

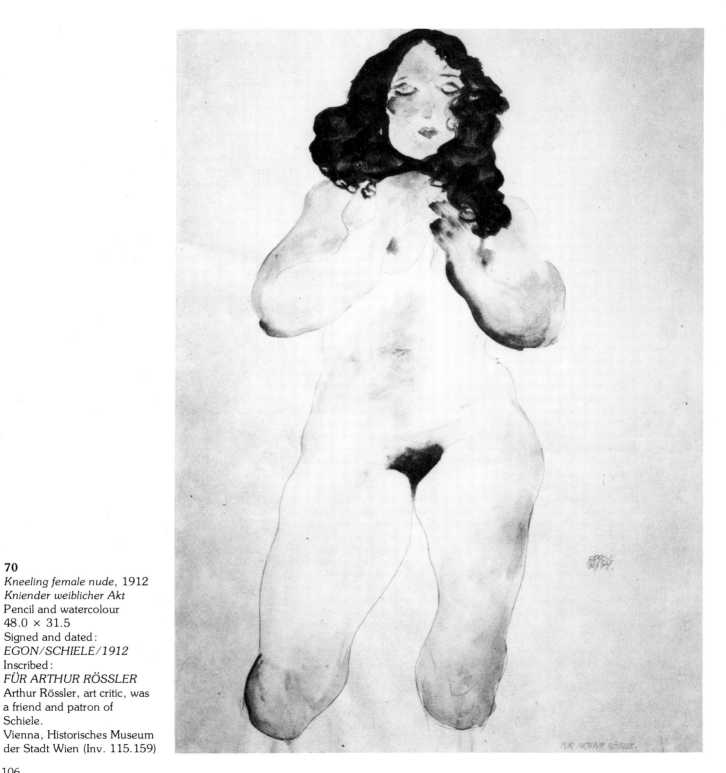

70
Kneeling female nude, 1912
Kniender weiblicher Akt
Pencil and watercolour
48.0 × 31.5
Signed and dated:
EGON/SCHIELE/1912
Inscribed:
FÜR ARTHUR RÖSSLER
Arthur Rössler, art critic, was
a friend and patron of
Schiele.
Vienna, Historisches Museum
der Stadt Wien (Inv. 115.159)

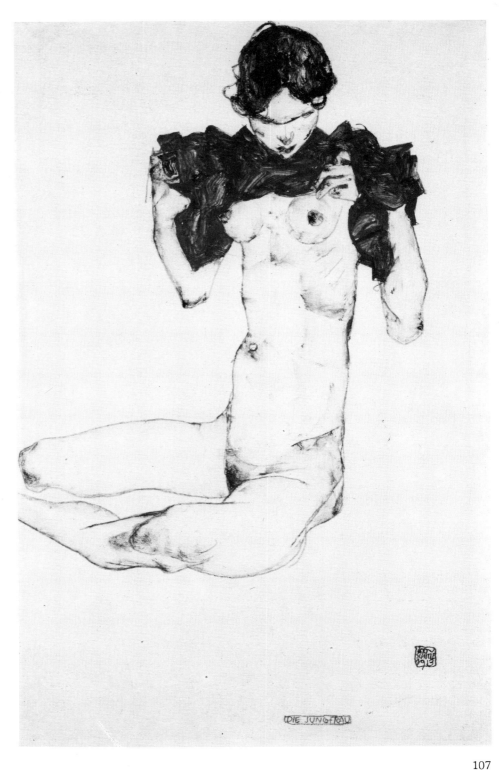

71
The Virgin, 1913
Die Jungfrau
Pencil and bodycolour
48.8 × 31.2
Signed and dated:
EGON/SCHIELE/1913
Inscribed: *DIE JUNGFRAU*
Zurich, Graphische
Sammlung der Eidg.
Technischen Hochschule

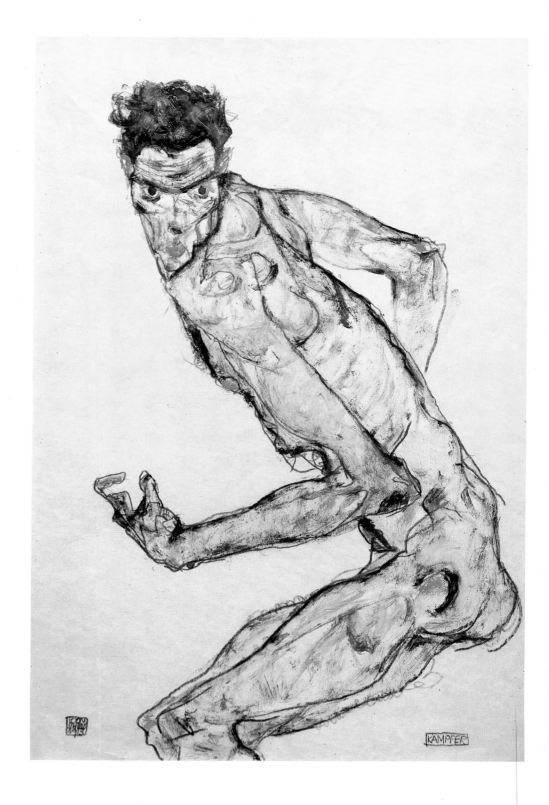

72
The Fighter, 1913
Der Kämpfer
Pencil and bodycolour
48.1 × 32.1
Signed and dated:
EGON/SCHIELE/1913
Inscribed: *KÄMPFER*
On the reverse: *Seated girl
(Wally)*
Graz, private collection

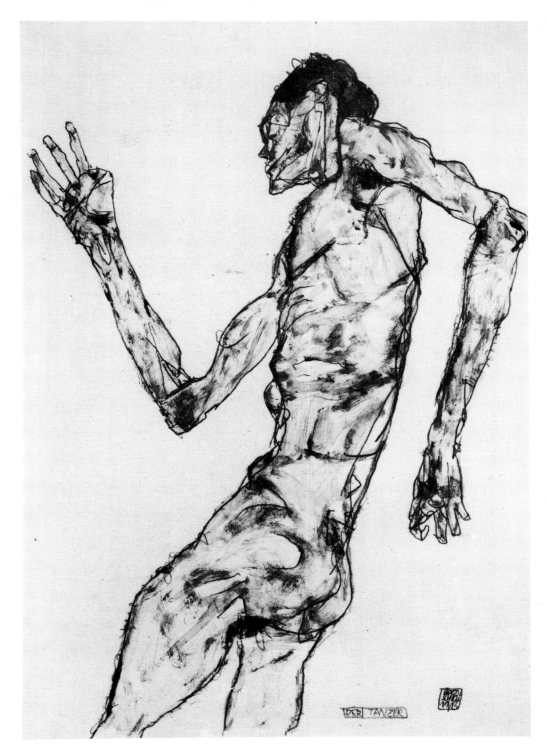

73
The Dancer, 1913
Der Tänzer
Pencil, watercolour and
bodycolour
47.8 × 32.0
Signed and dated:
EGON/SCHIELE/1913
Inscribed: *DER TÄNZER*
Vienna, Sammlung Dr Rudolf
Leopold

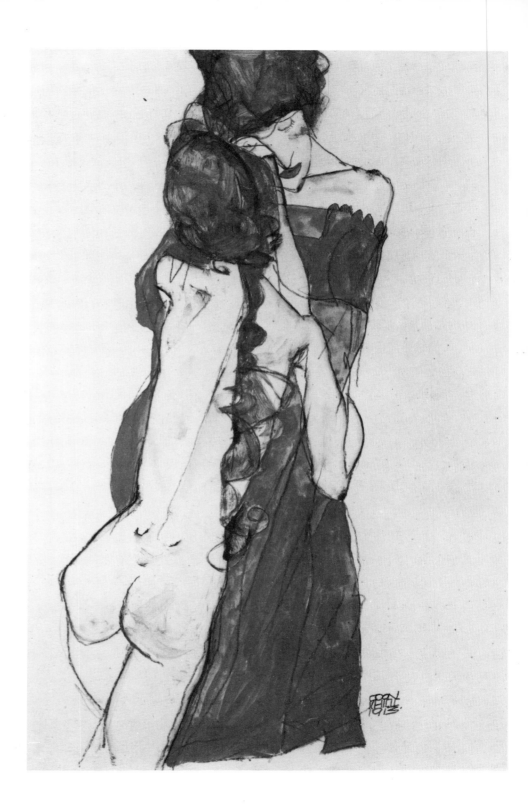

74
Mother and daughter, 1913
Mutter und Tochter
Pencil, watercolour and
bodycolour
47.9 × 31.8
Signed and dated:
EGON/SCHIELE/1913
Vienna, Sammlung Dr Rudolf
Leopold

110

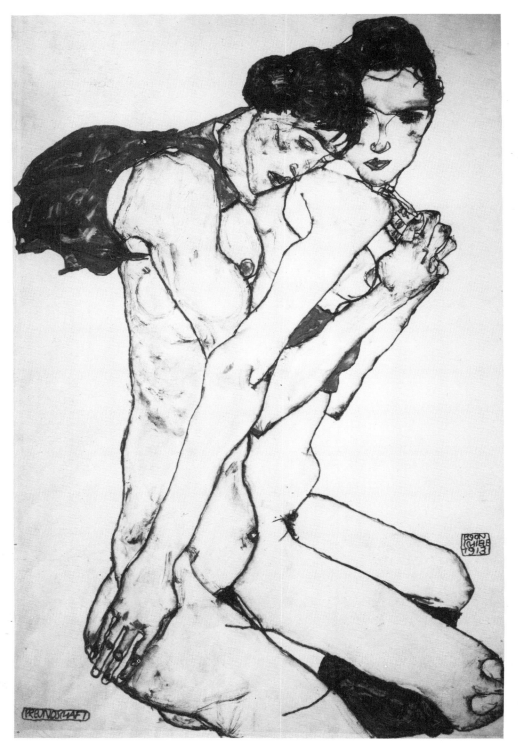

75
Friendship, 1913
Freundschaft
Pencil and bodycolour
48.2 × 32.0
Signed and dated:
EGON/SCHIELE/1913
Inscribed: *FREUNDSCHAFT*
New York, courtesy of Serge
Sabarsky Gallery

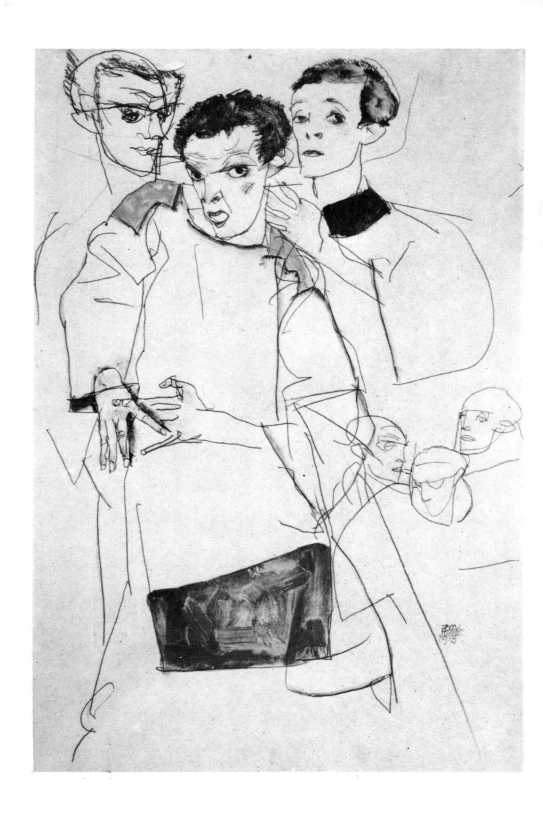

76
Triple self-portrait, 1913
Dreifaches Selbstporträt
Pencil and watercolour
48.4 × 32.0
Signed and dated:
EGON/SCHIELE/1913
London, Fischer Fine Art

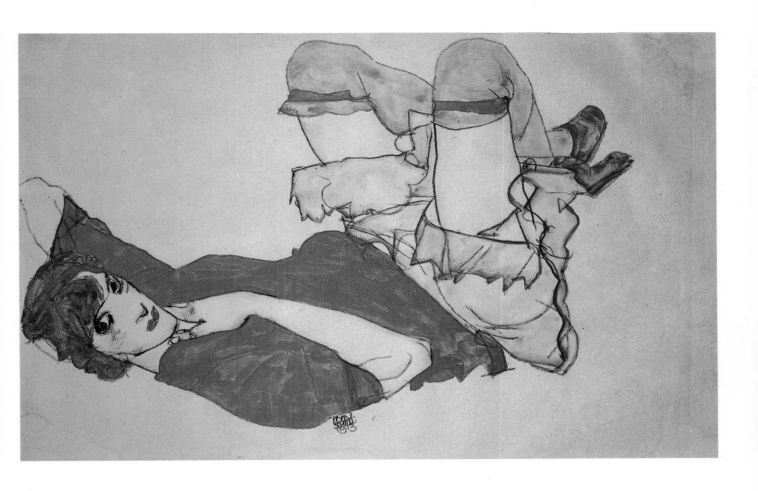

77
Wally in a red blouse, 1913
Wally mit roter Bluse
Pencil, watercolour and
tempera
Signed and dated:
EGON/SCHIELE/1913
One of the many portrait
studies of Wally Neuziel, who
lived with Schiele for some
years and acted as his model.

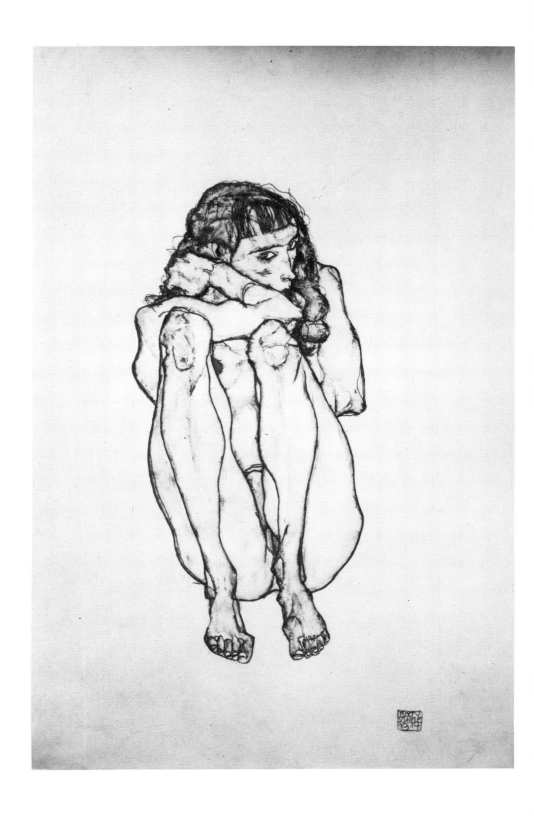

78
Seated nude, 1914
Sitzender Akt
Pencil, watercolour and
bodycolour
48.2 × 31.7
Signed and dated:
EGON/SCHIELE/1914
New York, courtesy of Serge
Sabarsky Gallery

114

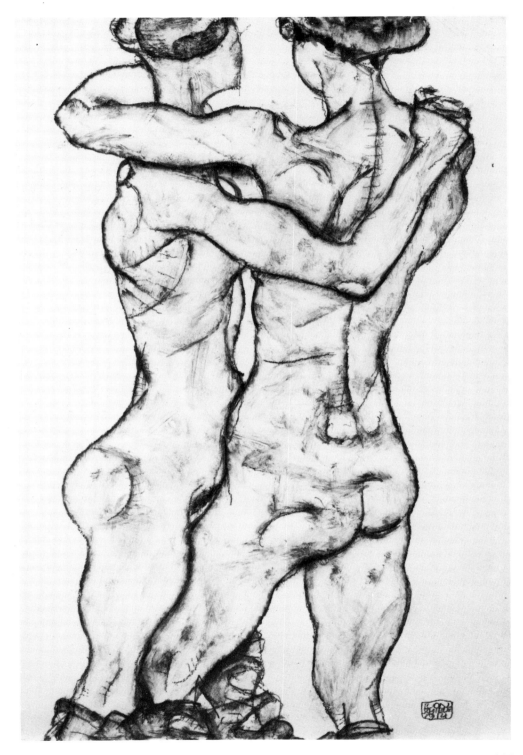

79
Two women embracing, 1914
Zwei sich umarmende Frauen
Pencil and bodycolour
48.4 × 32.0
Signed and dated:
EGON/SCHIELE/1914
Vienna, Sammlung Dr Rudolf
Leopold

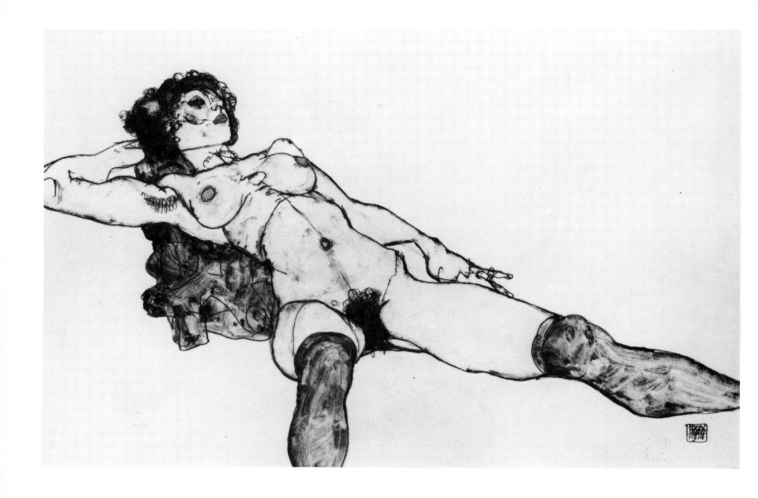

80
Reclining woman, 1914
Liegende Frau
Pencil and watercolour
31.5 × 48.1
Signed and dated:
EGON/SCHIELE/1914
Vienna, Graphische
Sammlung Albertina
(Inv. 26667)

116

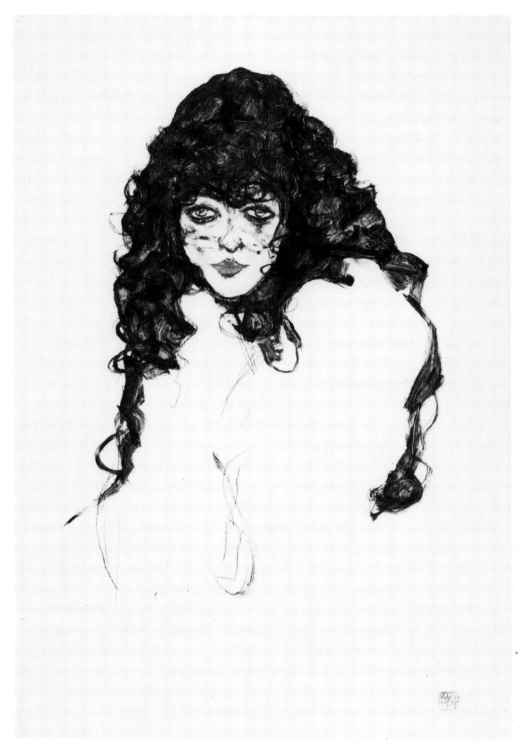

81
Portrait sketch, 1914
Porträtskizze
Pencil and watercolour
48.2 × 31.6
Signed and dated:
EGON/SCHIELE/1914
Munich, Staatliche
Graphische Sammlung

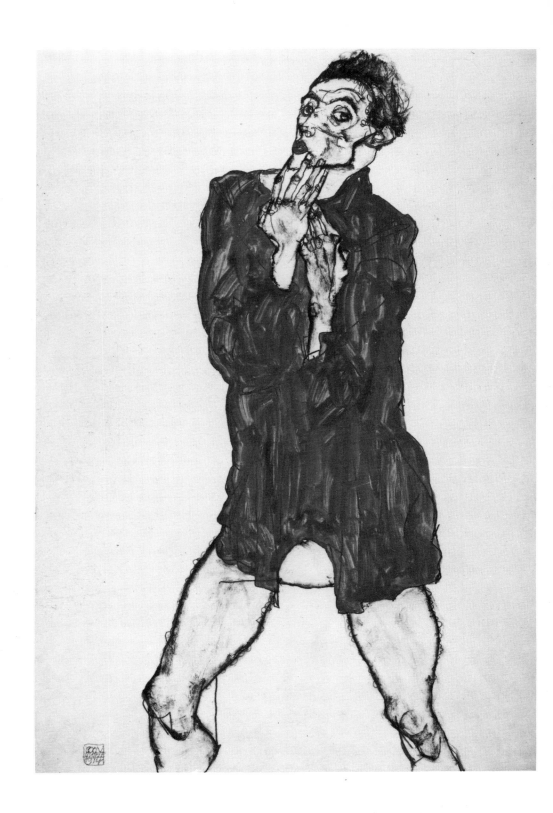

82
Self-portrait, 1914
Selbstbildnis
Bodycolour over pencil
48.5 × 32.0
Signed and dated:
EGON/SCHIELE/1914
Stuttgart, Graphische
Sammlung Staatsgalerie

118

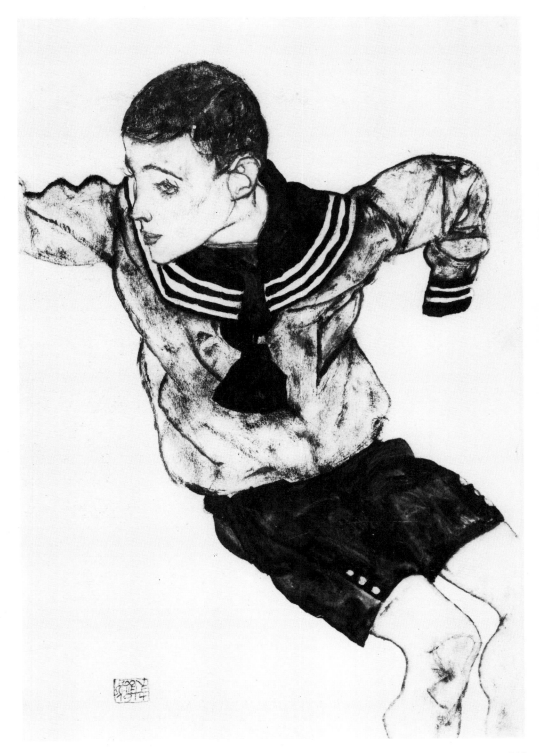

83
Boy in sailor suit, 1914
Knabe in Matrosenanzug
Pencil, crayon, watercolour
and bodycolour
47.0 × 31.0
Signed and dated:
EGON/SCHIELE/1914
Switzerland, private collection
Courtesy Fischer Fine Art,
London

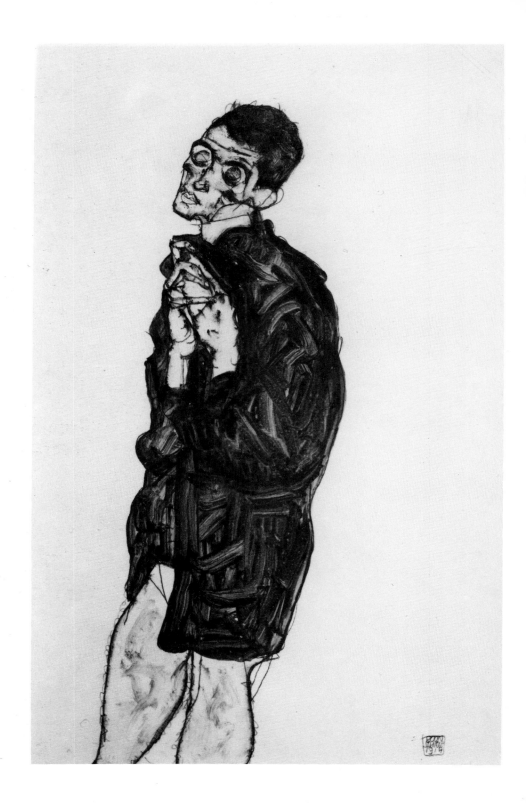

84
Self-portrait with eyes closed,
1914
Selbstdarstellung mit
geschlossenen Augen
Pencil and bodycolour
48.5 × 31.4
Signed and dated:
EGON/SCHIELE/1914
Vienna, Sammlung Dr Rudolf
Leopold

120

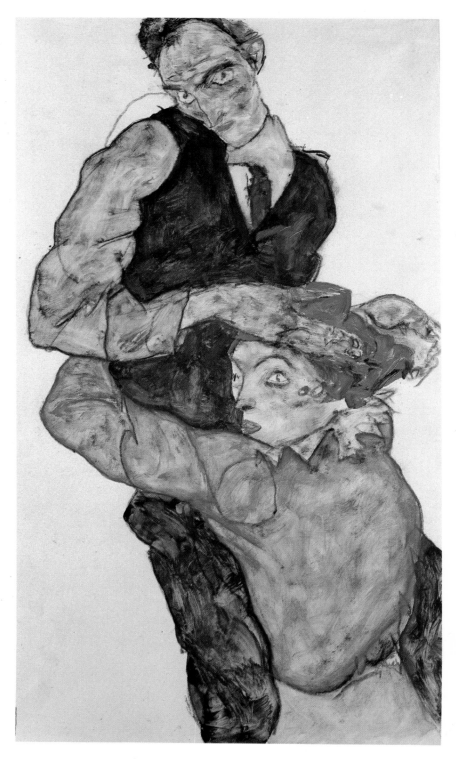

85
Lovers, 1914/1915
Liebespaar
Pencil and bodycolour
47.3 × 30.5
Self-portrait together with his
model Wally Neuziel
Vienna, Sammlung Dr Rudolf
Leopold

121

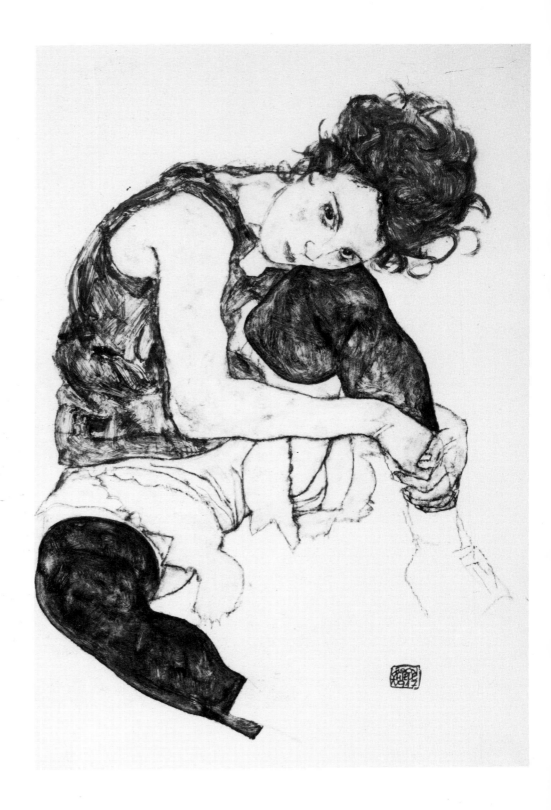

86
Seated girl, 1917
Sitzendes Mädchen
Black chalk and watercolour
46.0 × 30.5
Signed and dated:
EGON/SCHIELE/1917
Prague, Národní Galerie

122

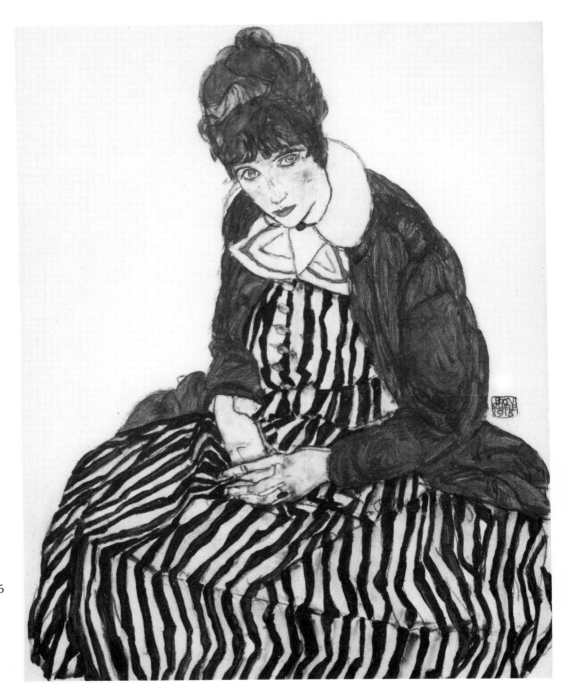

87
Portrait of Edith Schiele, 1915
Porträt Edith Schiele
Charcoal, watercolour and
bodycolour
50.5 × 38.5
Signed and dated:
EGON/SCHIELE/1915
Edith Harms married Schiele
in 1915. She died of Spanish
influenza on 28 October
1918, pregnant, three days
before her husband.

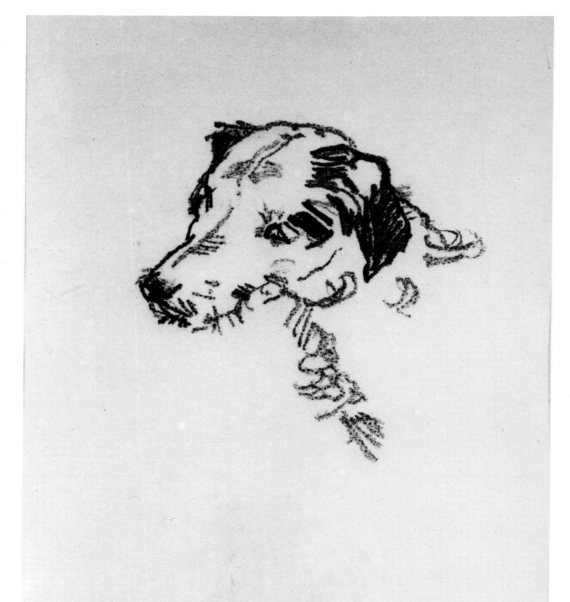

88
Head of a dog, 1915
Hundekopf
Black chalk
39.5 × 31.0
Signed and dated:
EGON/SCHIELE/1915
One of Schiele's few drawings
of animals.
Vienna, Niederöster-
reichisches Landesmuseum

124

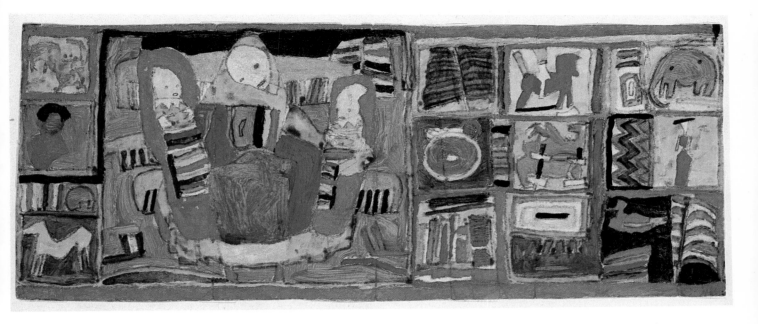

89
*Mother with children and
toys, c. 1915
Mutter mit Kindern und
Spielzug*
Oil on paper
17.5 × 43.5
Linz, Neue Galerie der Stadt
Linz - Wolfgang Gurlitt
Museum

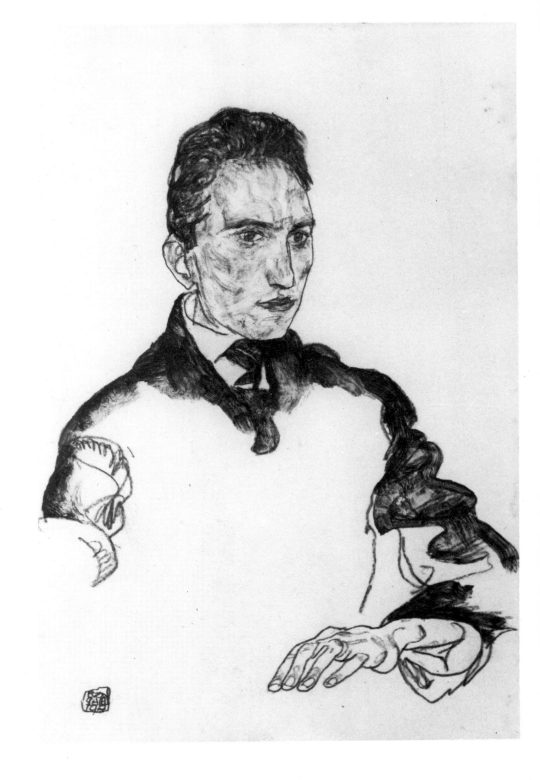

90
Portrait of Karl Grünwald,
1917
Bildnis Karl Grünwald
Pencil and bodycolour
45.0 × 29.5
Signed and dated:
EGON/SCHIELE/1917
Schiele met Oberleutnant Karl
Grünwald, an art dealer in
civilian life, during his military
service.
Private collection

126

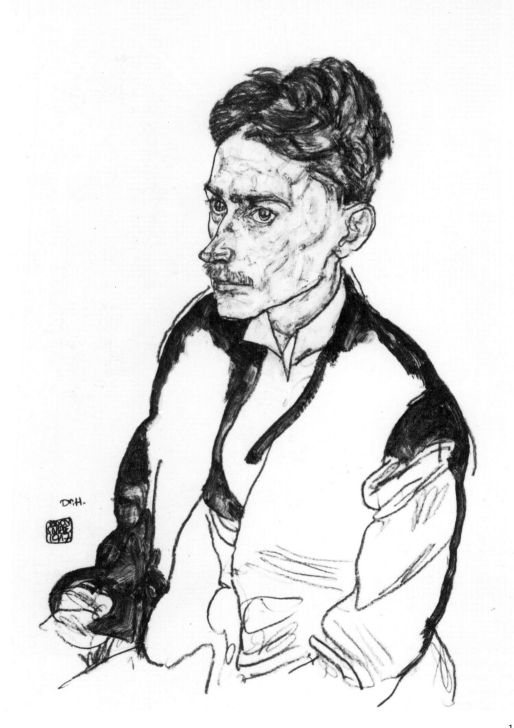

91
*The art historian F.M.
Haberditzl,* 1917
*Der Kunsthistoriker F.M.
Haberditzl*
Pencil, watercolour and
bodycolour
46.0 × 39.2
Signed and dated:
EGON/SCHIELE/1917
Inscribed: *Dr. H.*
On the reverse: *Dr. Haberditzl*
Private collection

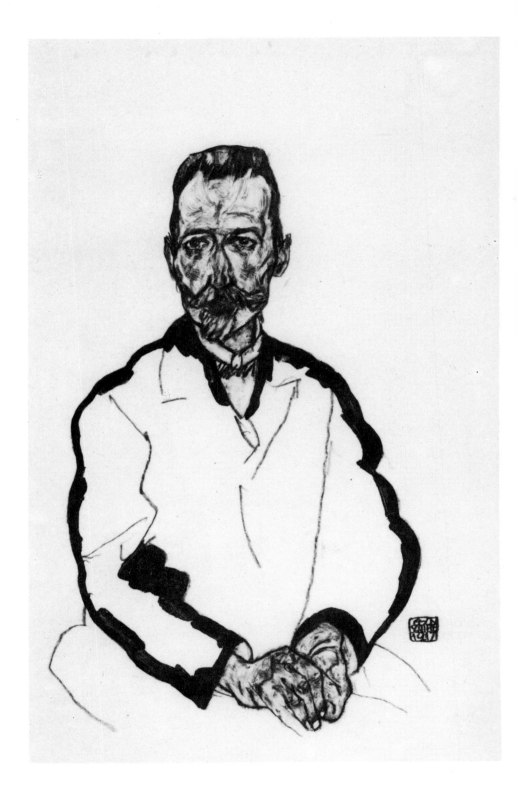

92
Portrait of Heinrich Benesch,
1917
Bildnis Heinrich Benesch
Pencil and watercolour
46.0 × 29.3
Signed and dated:
EGON/SCHIELE/1917
Heinrich Benesch, a Central
Inspector of Railways, was a
faithful friend and patron of
Schiele and a collector of his
work. Father of the art
historian and director of the
Albertina, Otto Benesch.

128

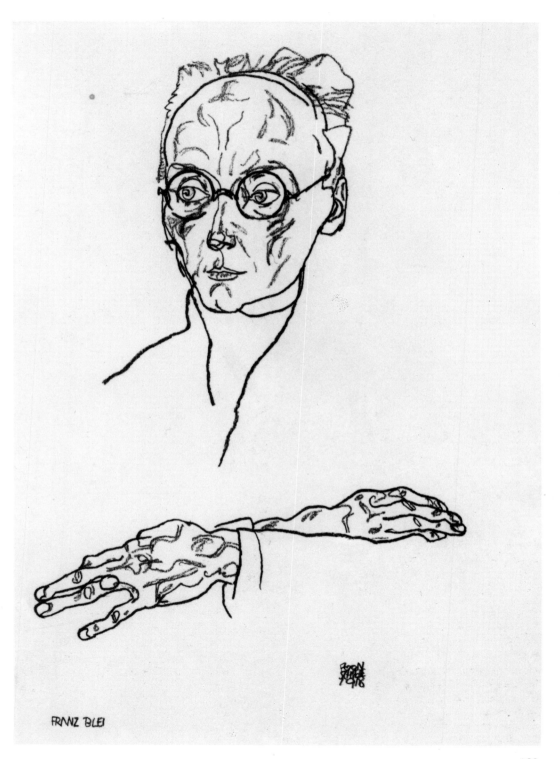

93
Portrait of the writer Franz Blei, 1918
Bildnis der Schriftstellers Franz Blei
Black chalk
47.2 × 30.2
Signed and dated:
EGON/SCHIELE/1918
Inscribed: *FRANZ BLEI*
Vienna, Historisches Museum der Stadt Wien

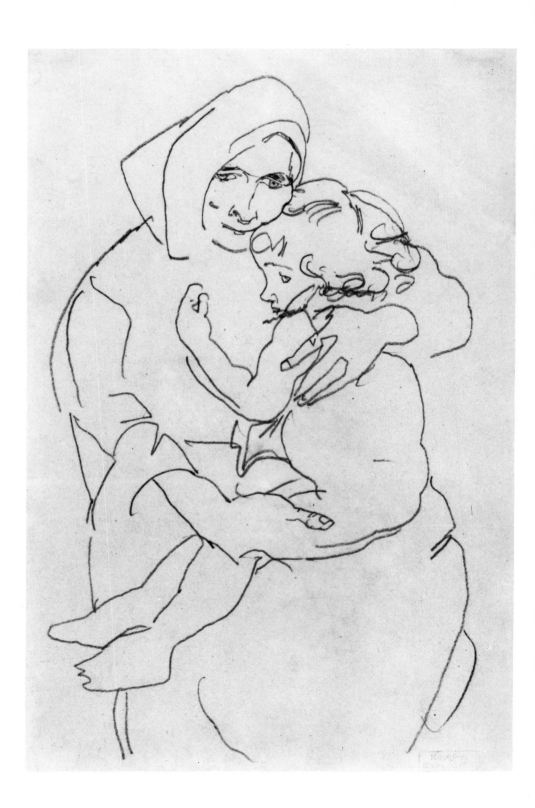

94
Mother and child
Mutter und Kind
Black chalk
46.0 × 30.0
Stamp of Estate
Brussels, private collection

130

95
Reclining female nude, 1918
Liegender weiblicher Akt
Black chalk
29.7 × 45.6
Graz, Neue Galerie am
Landesmuseum Joanneum

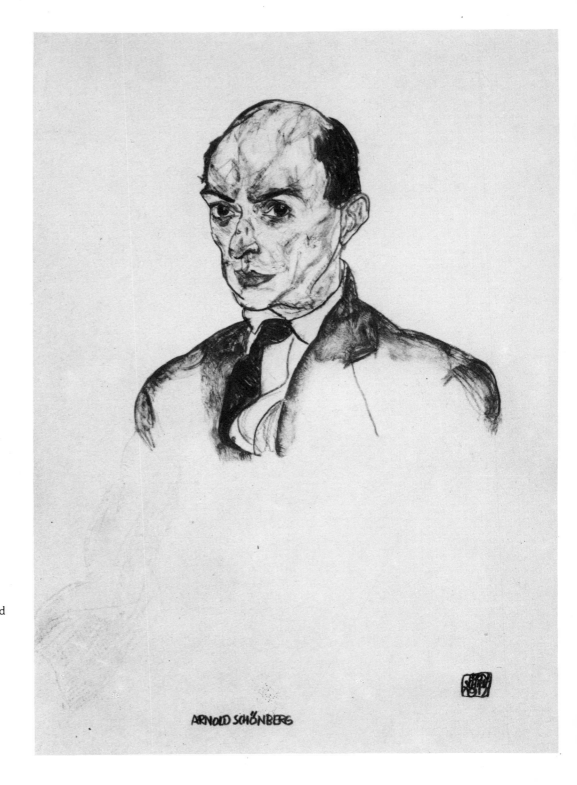

96
Arnold Schönberg, 1917
Black chalk, watercolour and
bodycolour
40.5 × 27.0
Signed and dated:
EGON/SCHIELE/1917
Inscribed:
ARNOLD SCHÖNBERG
Schiele drew a number of
portraits of the composer.
Collection The Earl and
Countess of Harewood

132

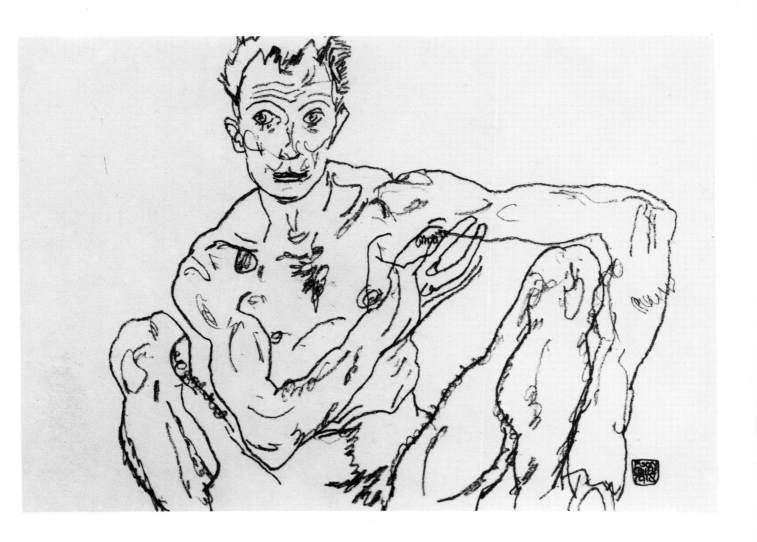

97
Squatting male nude (self-portrait), 1918
Kauernder männlicher Akt (Selbstbildnis)
Black chalk
30.1 × 47.1
Signed and dated:
EGON/SCHIELE/1918
Study for *The Family*
(Vienna, Österreichische Galerie)
Vienna, Graphische Sammlung Albertina
(Inv. 31345)

OSKAR KOKOSCHKA

Oskar Kokoschka was born on 1 March 1886 in Pöchlarn in Lower Austria, on the Danube. The house where he was born is now a documentation centre devoted to him. On leaving the Realschule in the 18th district of Vienna in 1904 he wanted originally to become a chemist, but attended the Kunstgewerbeschule in Vienna instead (1904-9). The teachers there were sympathetic to modern art and some had contacts with the Wiener Werkstätte, founded in 1903, for which Kokoschka did his earliest work. Later he came under the influence of Georges Minne. He evolved his own Expressionist style at much the same time as Schiele, 1908-9. On the outbreak of the First World War, he joined a crack regiment of dragoons as a volunteer, and was badly wounded in Galicia in 1915. He spent the rest of the war convalescing in Sweden and in Dresden, where he was appointed professor at the Academy in 1919. He died on 22 February 1980 at the age of ninety-four, leaving an immense œuvre.

Oskar's father, Gustav Kokoschka (1844-1924), was born in Prague and was a goldsmith. In later years, as partner in a relative's jewellery business, he often travelled to London and Paris. 'I was never very close to my father; yet he influenced me, and in a very different way from my mother.' (Kokoschka, *My Life*, London 1974, pp. 11-12.) The family lived in Vienna. Oskar's mother Romana, née Loidl (1863-1934), was one of the large family of an imperial forester. As her husband was away, she went to Pöchlarn, where her brother had a saw-mill, for Oskar's birth. 'That I did... manage to continue my education after elementary school I owe, as in so much else in the decisive phases of my life, to my mother. My father lived in a world of his own (*My Life*, p. 15).

One of the key figures on the Vienna art scene in the first years of the century was Josef Hoffmann (1870-1956), architect and craftsman. Co-founder, with Koloman Moser (craftsman, painter, 1868-1918), of the Wiener Werkstätte. Architect of the Hôtel Stoclet, Brussels, 1905-11, the interior decoration of which was also under his supervision. He was a good friend and patron of many young Austrian artists, such as Egon Schiele, on whose behalf he procured commissions throughout his life. He was also a friend of Gustav Klimt, and had an influence on the backgrounds Klimt painted in his female portraits between 1902 and 1907. It is not known whether or not Klimt actually worked as a designer for the Werkstätte. The young Kokoschka did a lot of work for the Werkstätte, 1906-8.

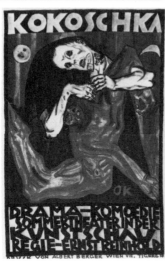

When Kokoschka's play *Murderer, Hope of Women* was given an improvised performance, he also designed the poster. 'The man is blood-red, the colour of life. But he is lying dead in the lap of a woman who is white, the colour of death. If in art the label "Expressionism" has a meaning, then this poster was one of its earliest manifestations.' (*My Life*, p. 28.) The hypersensitive Kokoschka seems to have taken it very badly that at the second Kunstschau Egon Schiele was placed on an equal footing with himself as an Expressionist artist. All at once he was not alone in the avant-garde. This is the probable reason for his animosity towards the younger man, which is otherwise almost inexplicable.

While the general public passed by his pictures in utter incomprehension, a storm broke out over his play, which attracted offensive reviews. 'I was angry at the insults I read every day in the Press where I saw myself treated as a criminal. So I had my head shaved in order to look the part.' (*My Life,* p. 28.)

From 1912 to 1915 Kokoschka was closely involved with Alma Mahler, the widow of the composer and conductor Gustav Mahler (1860-1911). He painted her and himself in *The Bride of the Wind (The Tempest)* (1914, Kunstmuseum, Basle). 'The next three years with him were one long, violent, loving struggle. Never before had I known such pain, such hell, such paradise.' (Alma Mahler-Werfel, *Erinnerungen,* 1958.)

She was the daughter of the Viennese landscape painter Emil Jakob Schindler (1842-92), and was looked after, following Schindler's death, by her step-father, the painter Carl Moll (1861-1945), who played an important role in the Secession as an exhibition organizer.

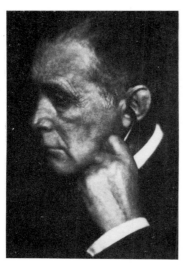

The counterpart to Hoffmann was Adolf Loos (1870-1933). Having trained as an architect in Dresden and the United States, from 1898 onwards, he was the proponent of a new, functional style of building that renounced all ornamentation. He was a friend of Kokoschka's from 1908, let him paint his portrait, and tried to find work for him. He persuaded him to dissolve his links with the Werkstätte, and to go to Berlin, where he attached himself to the circle around Herwarth Walden (of *Der Sturm),* and was taken under contract by Paul Cassirer in 1910. Kokoschka wrote about Loos: 'I took all he did for granted, without ever thanking him.' (*My Life,* p. 85.)

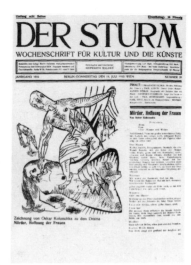

'Herwarth Walden was a kind of Mahdi, who preached a lofty doctrine of Progress as a path to a more exalted spiritual existence in a new and better world. He was a fanatic in the cause of Expressionism. What is nowadays labelled Expressionism could have come into existence only in Germany, where there was a desire to carry art to the masses, to the 'new man', as a reaction against Jugendstil or Art Nouveau, which set out only to beautify the surface and made no appeal to the inner life. Expressionism… was a sign of the times, not an artistic fashion.' (*My Life,* p. 66.)

Georges Minne (1866-1941), Belgian sculptor and graphic artist. His most important work, dating from 1898, is the fountain surrounded by five kneeling boys. The figures were exhibited in Vienna by the Secession. 'What impressed me most were the sculptures of Minne. In their chaste forms and their inwardness, I seemed to find a rejection of the two-dimensionality of Jugendstil.' (*My Life,* pp. 21-2.)

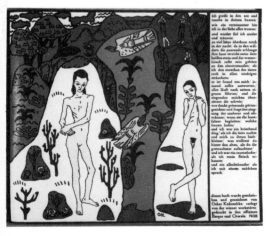

Minne's influence is particularly in evidence in Kokoschka's book *The Dreaming Youths,* published by the Werkstätte in 1908 and dedicated to Gustav Klimt. The commission was for a book for children, but it became a *roman à clef,* based on his romance with the Swedish girl Li. It can still not be said with certainty whether Minne's influence on Schiele was direct or came to him via Kokoschka.

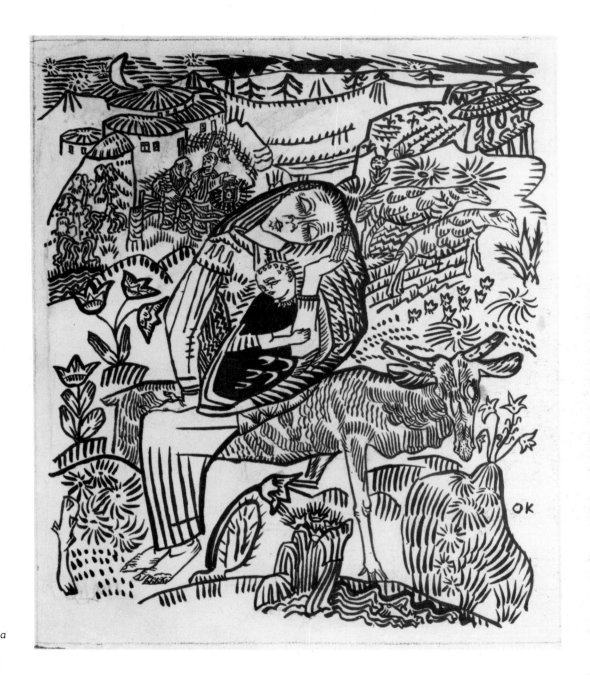

98
Mother with child riding on a hind
Mutter mit Kind, auf Hindin reitend
India ink with brush
24.5 × 21.0
Monogrammed: *OK*
Vienna, Graphische
Sammlung Albertina
(Inv. 31346)

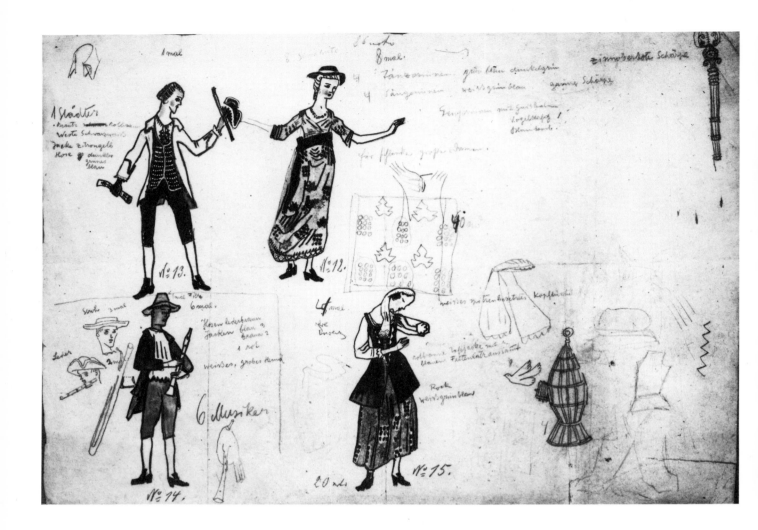

99
Costume designs for the
Jubilee Procession of 1908
Kostümentwürfe für den
Festzug 1908
Pencil, india ink, watercolour
and bodycolour
31.8 × 45.0
Vienna, Historisches Museum
der Stadt Wien (Inv. 115.125)

140

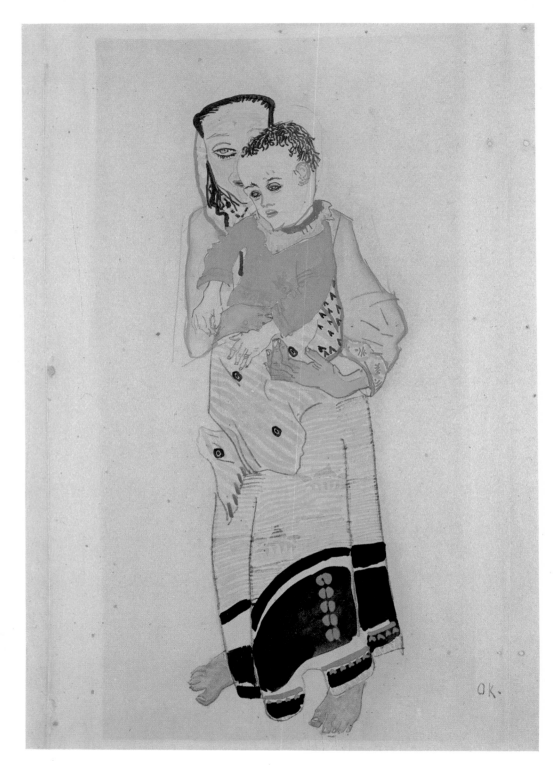

100
Mother and child, 1907/8
Mutter und Kind
Watercolour on pencil and
india ink
45.0 × 31.2
Monogrammed: *OK*.
Vienna, Historisches Museum
der Stadt Wien

141

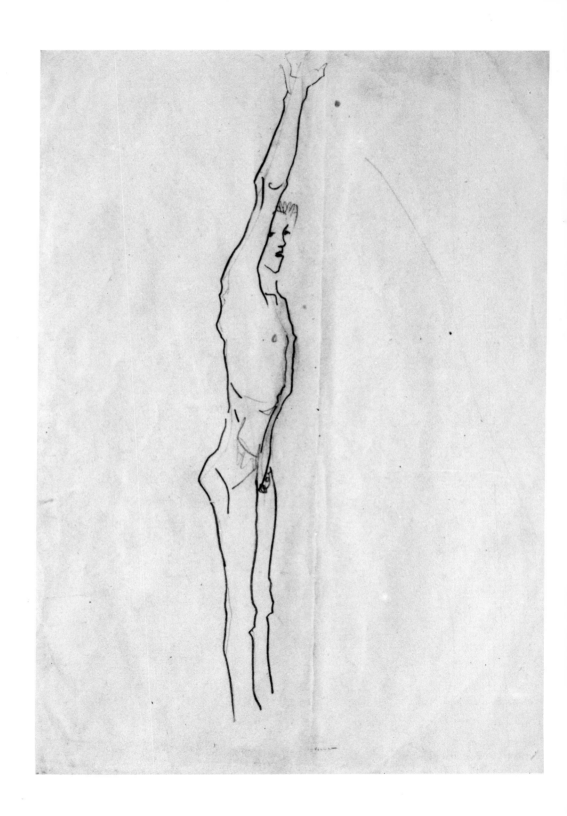

101
Nude study, 1907
Aktstudie
Pencil
45.5 × 31.5
The Hague, Haags
Gemeentemuseum
(Inv. T 44 - 1927)

142

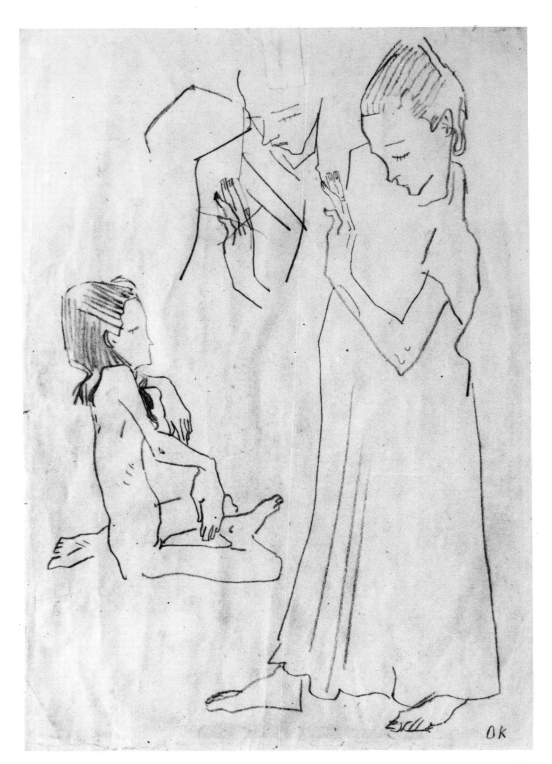

102
Three sketches of a girl, 1907
Drei Mädchenskizzen
Pencil
42.0 × 28.0
The Hague, Haags
Gemeentemuseum
(Inv. T 43 - 1927)

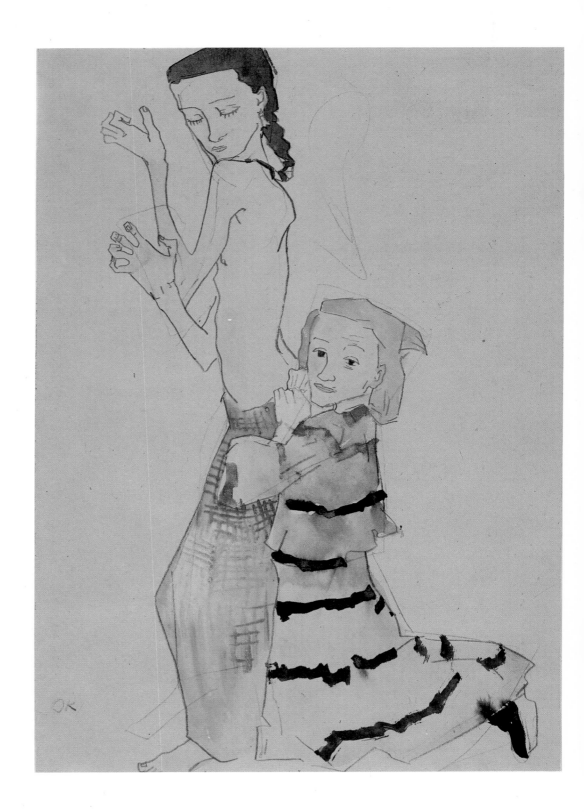

103
Two girls (Trying on the costume), 1907
Zwei Mädchen (Die Kostümprobe)
Pencil and watercolour
44.0 × 30.7
Monogrammed: *OK*
Private collection

144

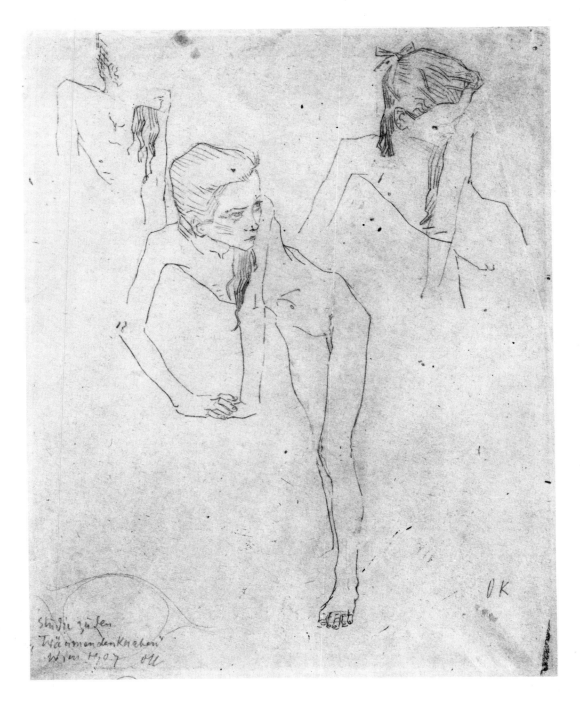

104
*Study for 'The dreaming
youths',* 1907
*Studie zu den 'Träumenden
Knaben'*
Pencil
37.1 × 28.7
Monogrammed: *OK*
Inscribed: *Studie zu den
'Träumenden Knaben'/Wien
1907 OK*
Basle, Kunstmuseum
Kupferstichkabinett

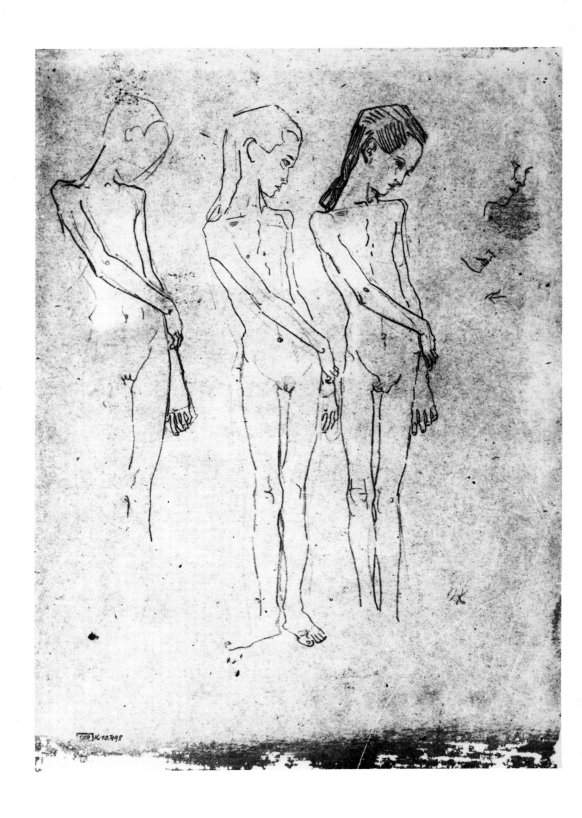

105
Three girl nudes, c. 1907
Drei Mädchenakte
Pencil
45.0 × 31.5
Monogrammed: *OK*
Prague, Národní Galerie

146

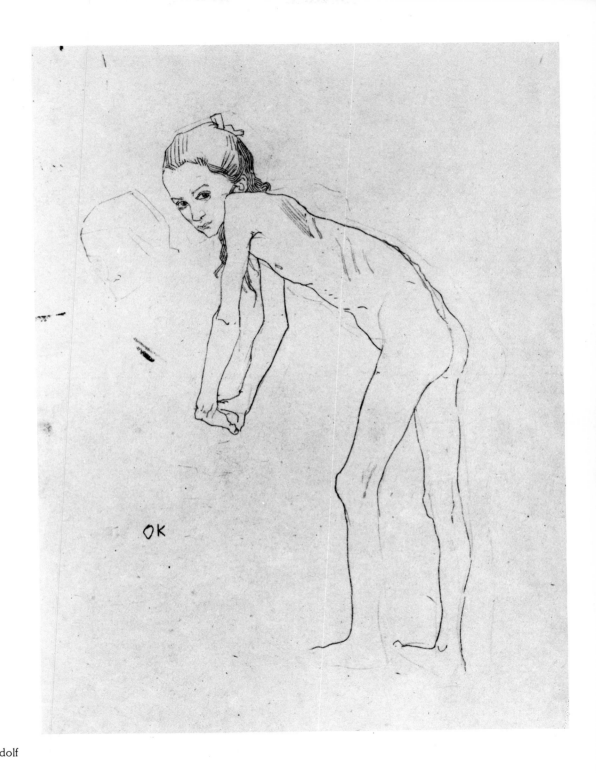

106
*Nude girl leaning on her
hands*, 1908
*Sich aufstützender
Mädchenakt*
Pencil
45.0 × 31.0
Monogrammed: *OK*
Vienna, Sammlung Dr Rudolf
Leopold

147

107
Sketch leaf, 1907
Skizzenblatt
Pencil
45.0 × 31.5
The Hague, Haags
Gemeentemuseum
(Inv. T 45 - 1927)

148

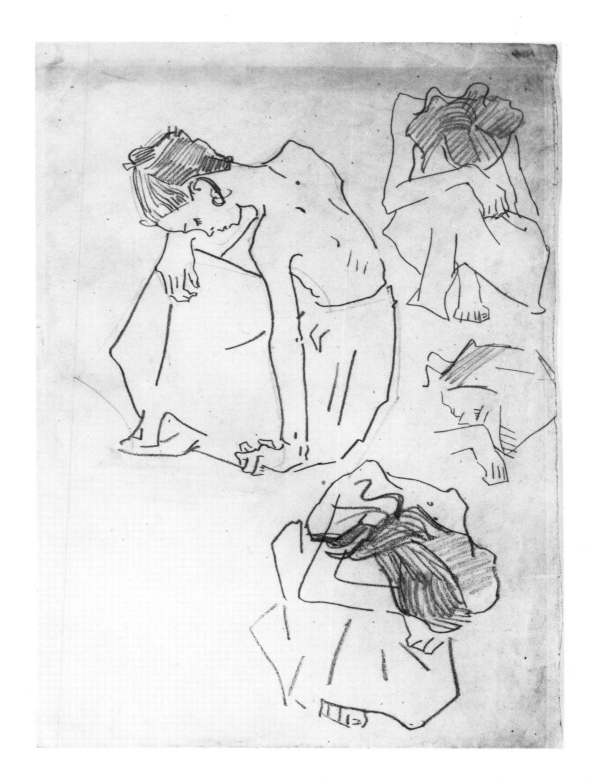

108
Sketch leaf with three
crouching girls, c. 1908
Skizzenblatt mit drei
kauernden Mädchen
Pencil
44.8 × 31.5
Vienna, Graphische
Sammlung Albertina
(Inv. 31449)

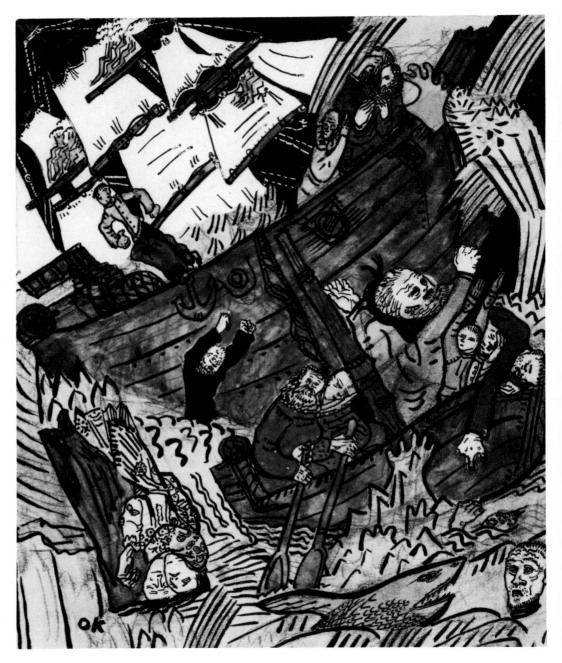

109
Storm at sea
Seesturm
Pen, india ink and bodycolour
20.9 × 16.7
Monogrammed: *OK*
Basle, Kunstmuseum
Kupferstichkabinett

150

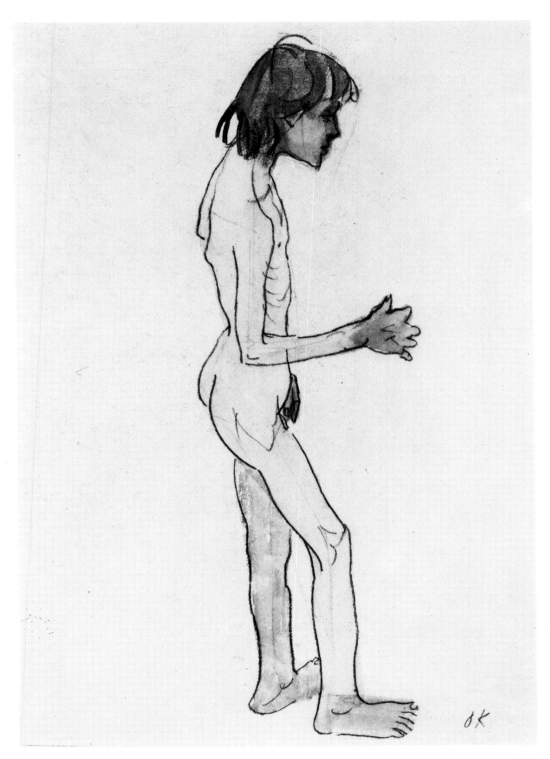

110
Savoyard boy, c. 1912
Savoyardenknabe
Black chalk and watercolour
44.0 × 32.0
Monogrammed: *OK*
Belongs to a group of similar
studies.
Private collection

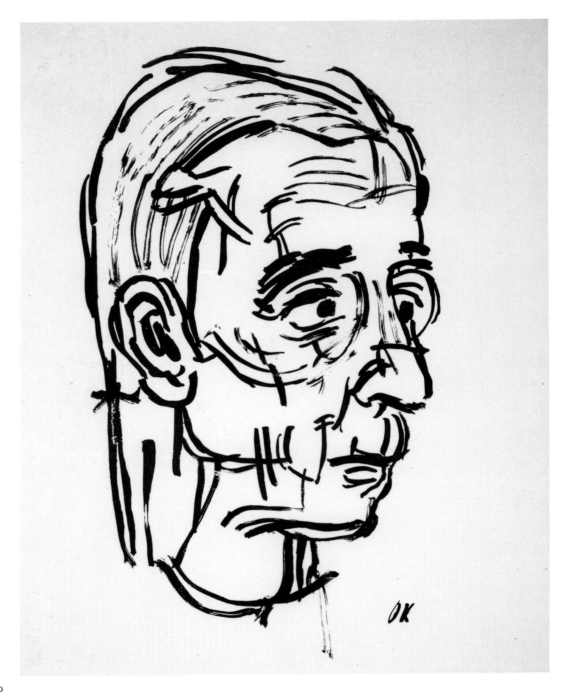

111
Portrait of Rudolf Blümmer
Bildnis Rudolf Blümmer
India ink with brush
34.5 × 30.0
Monogrammed: *OK*
Rudolf Blümmer was one of
the most faithul contributors to
the magazine *Der Sturm,*
edited by Herwarth Walden,
for which Kokoschka also
made drawings.

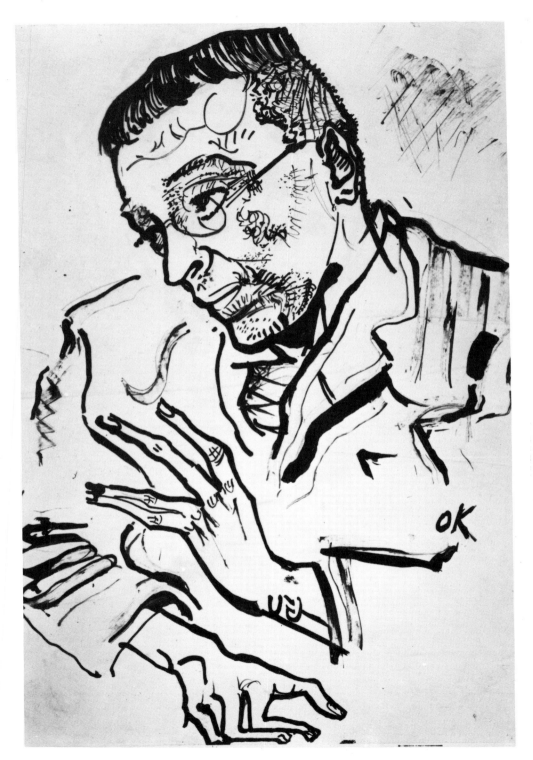

112
Portrait of Karl Kraus,
1909/1910
Bildnis Karl Kraus
India ink with pen and brush
29.7 × 20.6
Monogrammed: *OK*
Karl Kraus, editor of the
magazine *Die Fackel*, was one
of the leading literary figures
in Vienna. This portrait was
reproduced in the magazine
Der Sturm, 12, Berlin 1910.
Zurich, Sammlung Walter
Feilchenfeldt

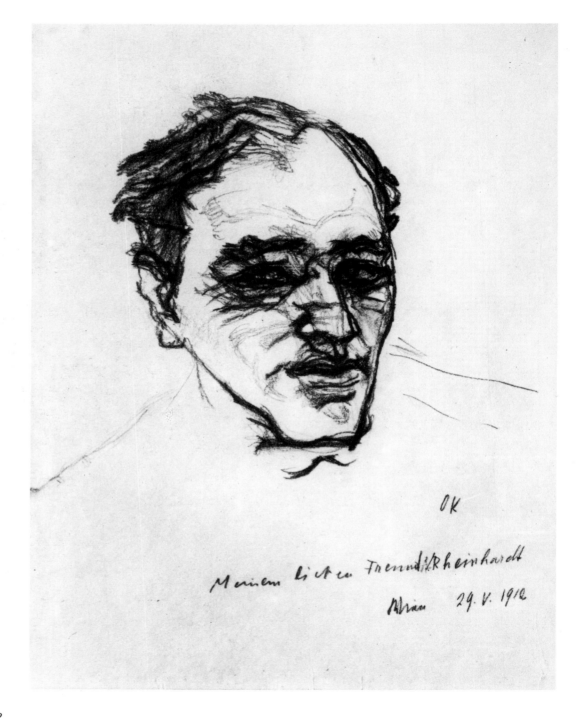

113
*Portrait of Emil Alfons
Rheinhardt*, 1912
*Bildnis Emil Alfons
Rheinhardt*
Charcoal
44.2 × 33.8
Monogrammed: *OK*
Inscribed: *Meinem lieben
Freund (N?)
Rheinhardt/Wien 29.V.1912*
Vienna, Graphische
Sammlung Albertina

154

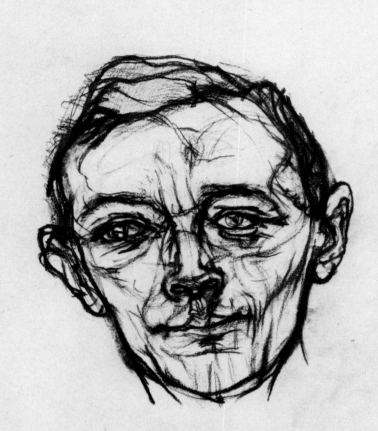

114
Portrait of the art historian
Karl-Maria Swoboda, c. 1912
Bildnis der Kunsthistorikers
Karl-Maria Swoboda
Charcoal
42.8 × 33.6
Monogrammed: *OK*
Inscribed: *Meinem Freund*
Karl Maria Swoboda
Hamburg, Hamburger
Kunsthalle

115
Landscape near Naples
Landschaft bei Neapel
Charcoal
25.5 × 37.0
Monogrammed: *OK*
Zurich, Sammlung
M. Feilchenfeldt

156

116
Landscape near Mürren,
1913
Landschaft bei Mürren
Charcoal
34.5 × 45.0
Monogrammed: *OK*
Stuttgart, Graphische
Sammlung Staatsgalerie

117
Horses grazing
Weidende Pferde
Charcoal
33.1 × 44.9
Monogrammed: *OK*
Vienna, Graphische
Sammlung Albertina
(Inv. 31008)

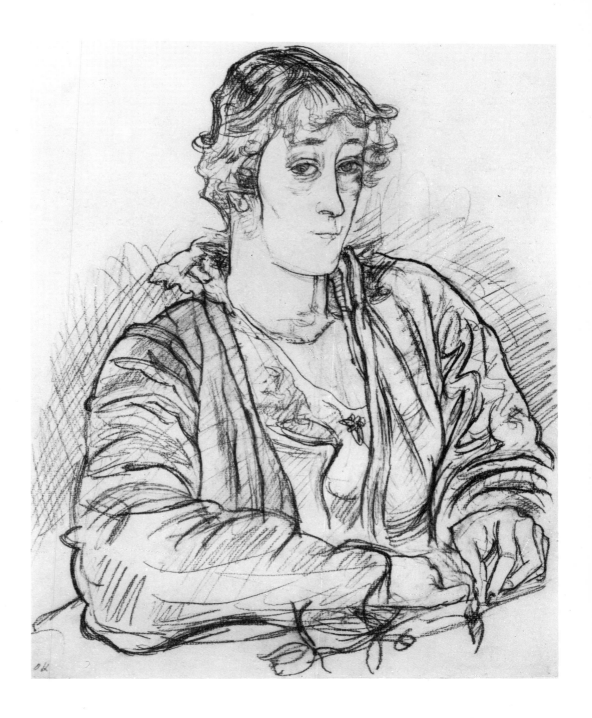

118
Portrait of a lady, c. 1914
Porträt einer Dame
Charcoal
48.0 × 40.0
Monogrammed: *OK*
Salzburg, Salzburger
Landessammlungen —
Rupertinum (Inv. 2289)

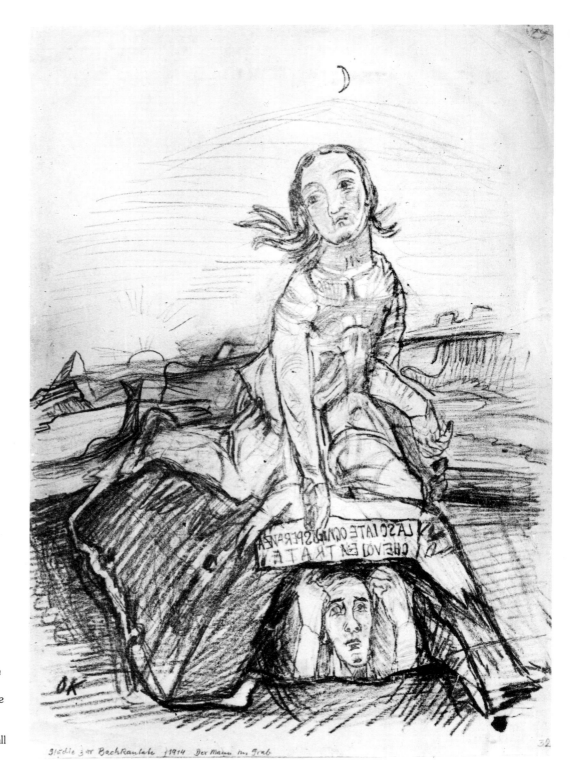

119
Fear
Die Furcht
Chalk
49.5 × 34.5
Monogrammed: *OK*
Inscribed: *Studie zur Bachkantate 1914 Der Mann im Grab* [Study for the Bach Cantata 1914 The Man in the Grave]; *LASCIATE OGNI SPERANZA CHE VOI ENTRATE* [Abandon hope all ye who enter here]

160

120
Study for 'Bach Cantata',
1914
Studie zur 'Bachkantate'
Chalk
35.5 × 27.5
Monogrammed: *OK*
Inscribed: *zu Bachkantate*
1914 OK
Salzburg, Salzburger
Landessammlungen
-Rupertinum (Inv. 1131)

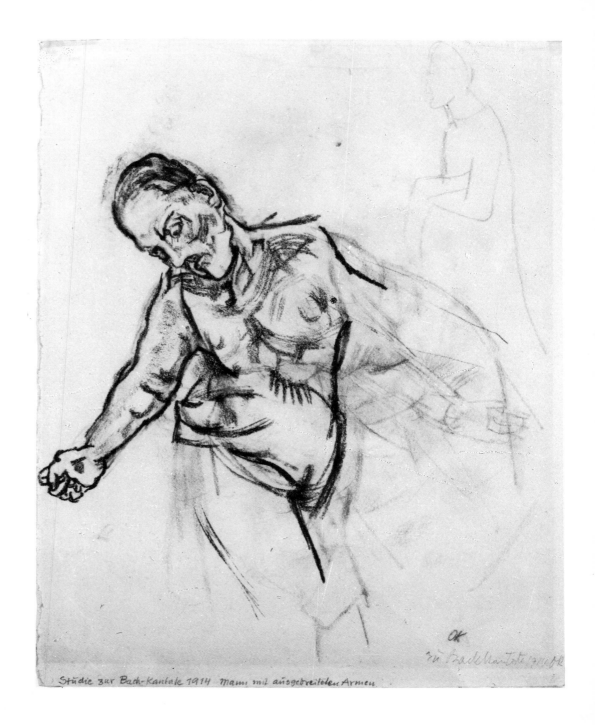

Studie zur Bach-Kantate 1914 Mann mit ausgebreiteten Armen

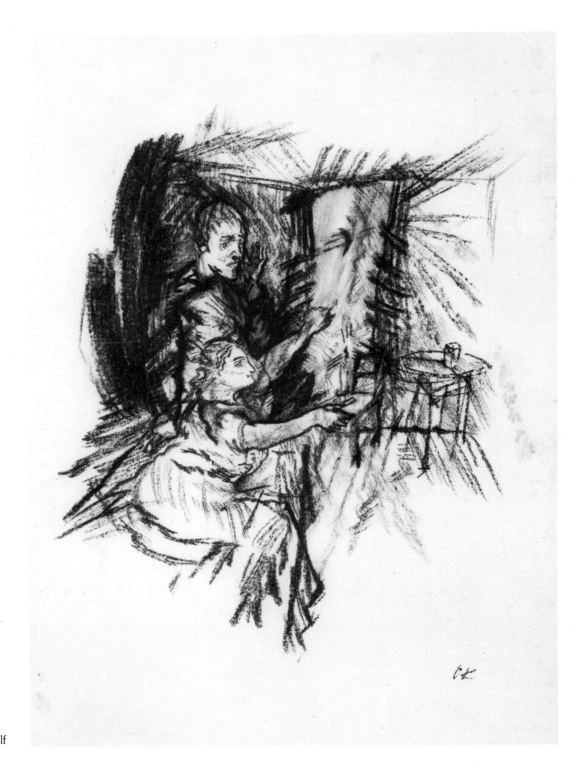

121
Couple by candlelight, 1913
Das Paar im Kerzenlicht
Black chalk
46.9 × 29.7
Drawing for *Columbus*
portfolio
Vienna, Sammlung Dr Rudolf
Leopold

162

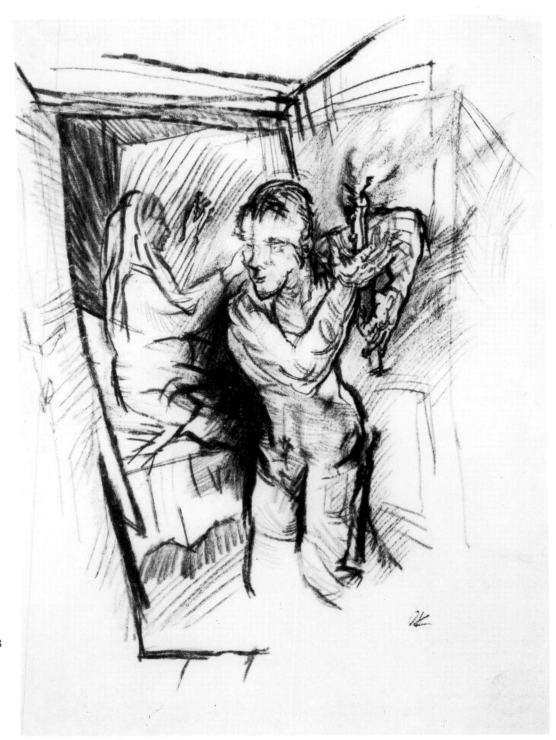

122
The parting of the ways, 1913
Am Scheidewege
Black chalk
42.5 × 29.6
Drawing for *Columbus*
portfolio
Vienna, Sammlung Dr Rudolf
Leopold

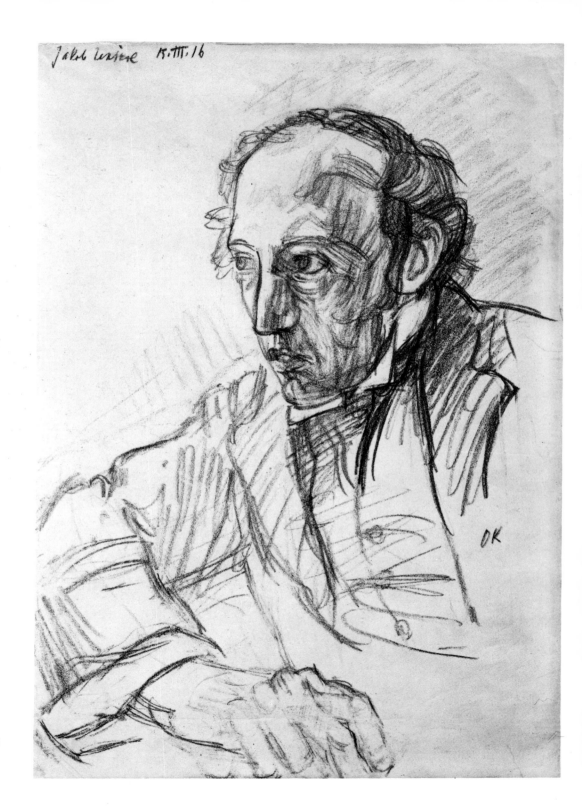

123
Portrait of J. Texière
Bildnis J. Texière
Chalk
49.5 × 34.6
Monogrammed: *OK*
Jakob Texière was a Danish
actor and reciter.
Private collection

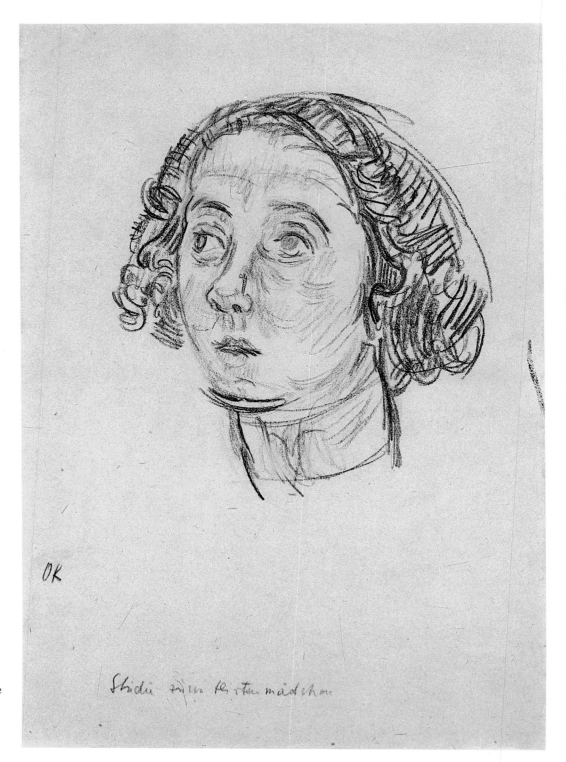

124
Head of a woman, c. 1916
Frauenkopf
Blue crayon
50.3 × 34.3
Monogrammed: *OK*
Inscribed: *Studie zum*
Hirtenmädchen [Study for the
Shepherd Girl]
Salzburg, Salzburger
Landessammlungen —
Rupertinum (Inv. 2282)

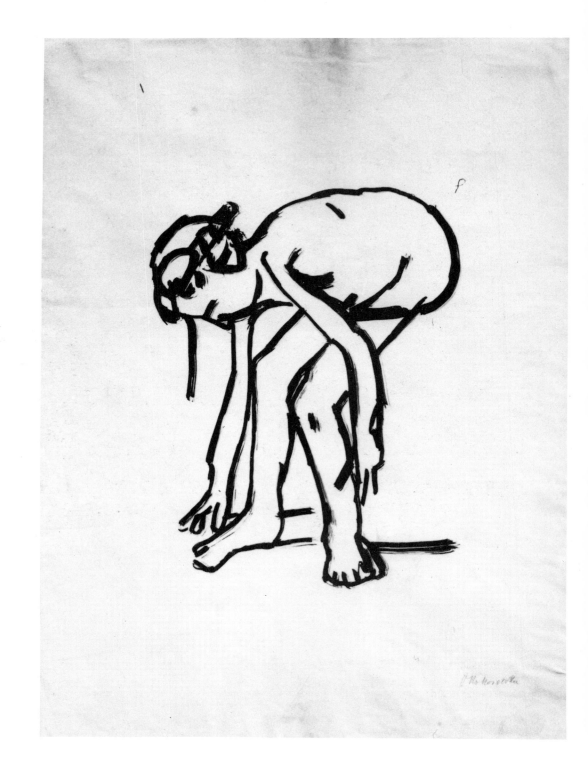

125
Girl bending
Sich bückendes Mädchen
India ink with brush
65.0 × 51.0
Signed: *O Kokoschka*
Private collection

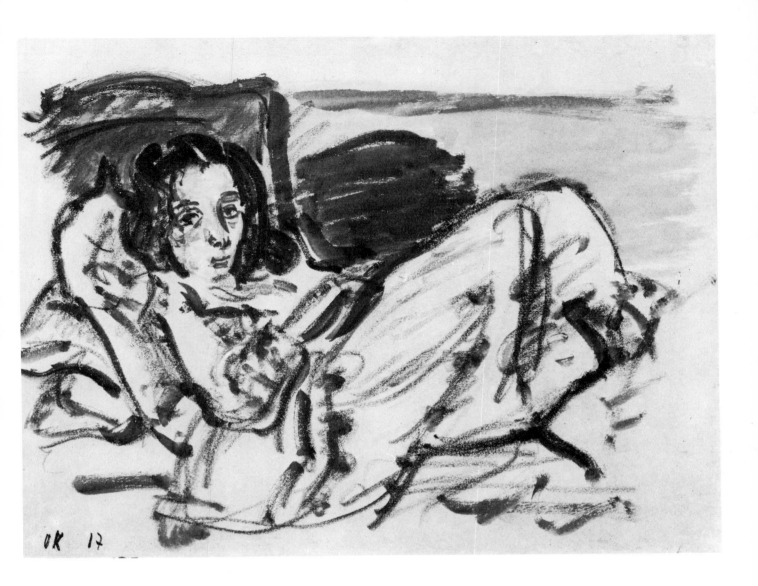

126
The sick girl (Käte Richter),
1917
*Das kranke Mädchen (Käte
Richter)*
Watercolour on charcoal
32.5 × 44.0
Monogrammed and dated:
OK 17
The actress Käte Richter had
been friendly with Kokoschka
since about 1916.
Private collection

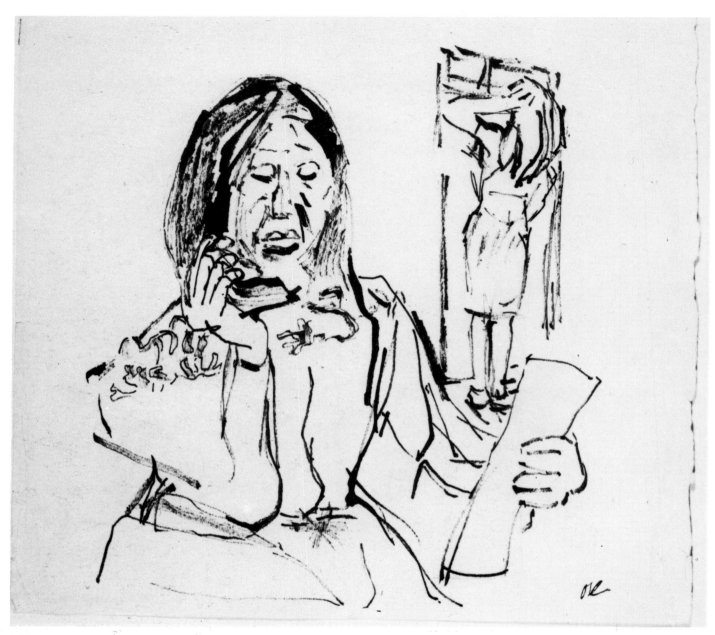

127
Woman reading
Lesende Frau
India ink with brush
22.7 × 24.5
Vienna, Graphische
Sammlung Albertina
(Inv. 31379)

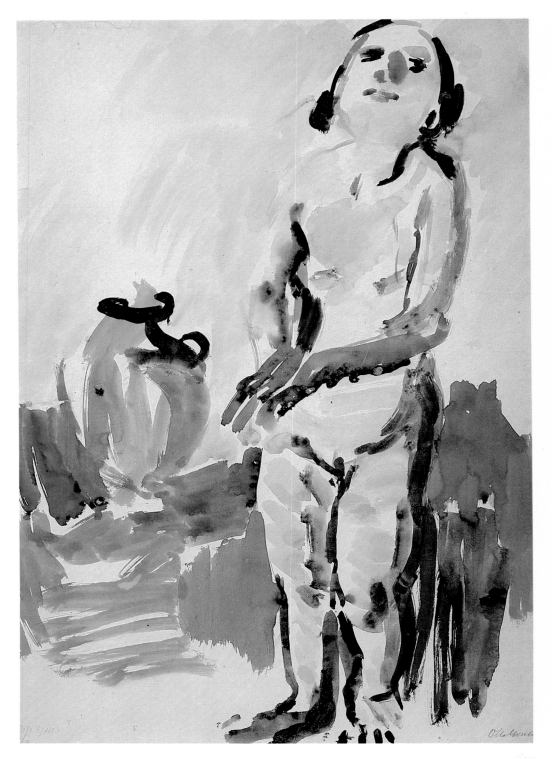

128
Standing nude girl, c. 1920
Stehender Mädchenakt
Watercolour
69.0 × 48.2
Signed: *O Kokoschka*
Basle, Kunstmuseum
Kupferstichkabinett

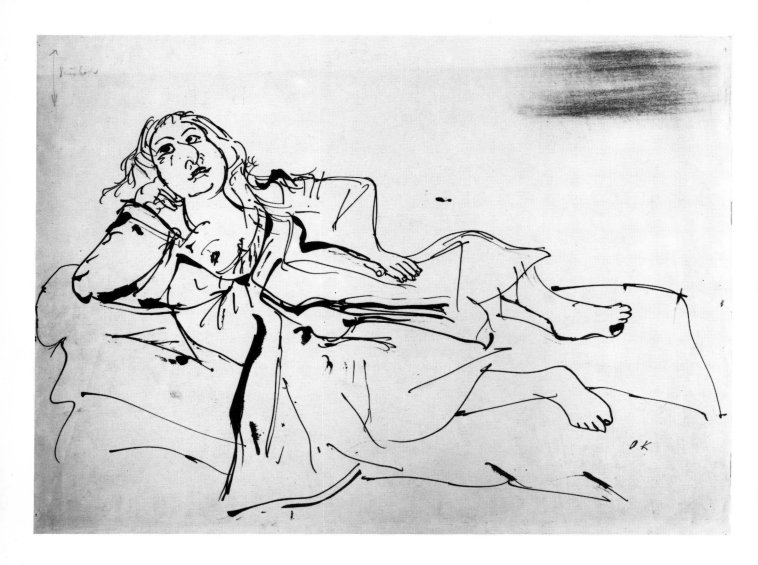

129
Study for 'Woman in Blue'
Studie für 'Frau in Blau'
India ink with pen
37.5 × 52.0
Monogrammed: *OK*
Kokoschka did a large
number of drawings for the
picture *Frau in Blau*
(Staatsgalerie, Stuttgart).
Stuttgart, Graphische
Sammlung Staatsgalerie

170

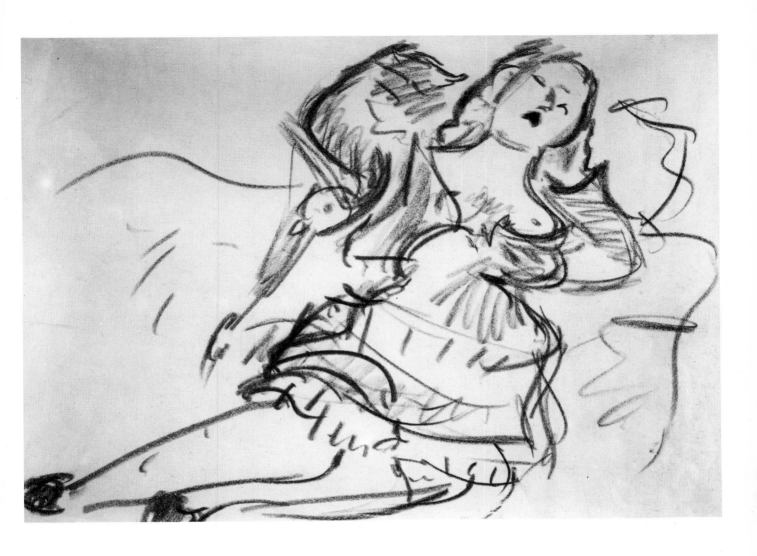

130
Study for 'Woman in Blue',
1919
Studie für 'Frau in Blau'
Green chalk
38.5 × 52.5
Stuttgart, Graphische
Sammlung Staatsgalerie

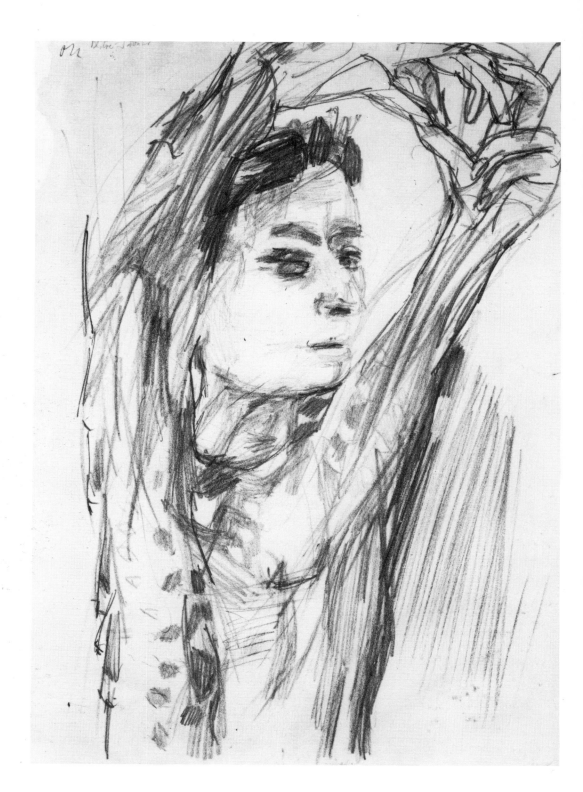

131
Girl with arms raised, 1920
Mädchen mit erhobenen
Armen
Charcoal
68.5 × 48.3
Monogrammed: *OK*
Private collection

172

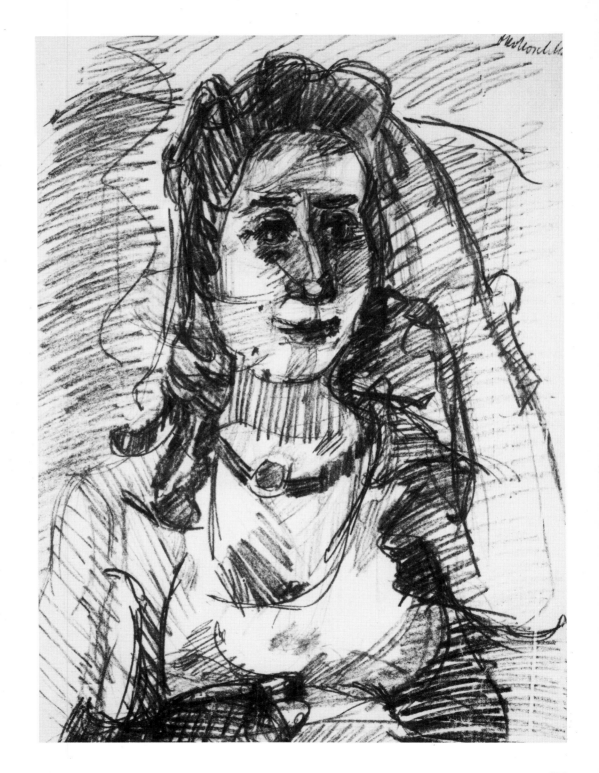

132
Woman with arm raised,
c. 1920
Frau mit erhobenem Arm
Charcoal
66.0 × 48.3
Signed: *O Kokoschka*
Private collection

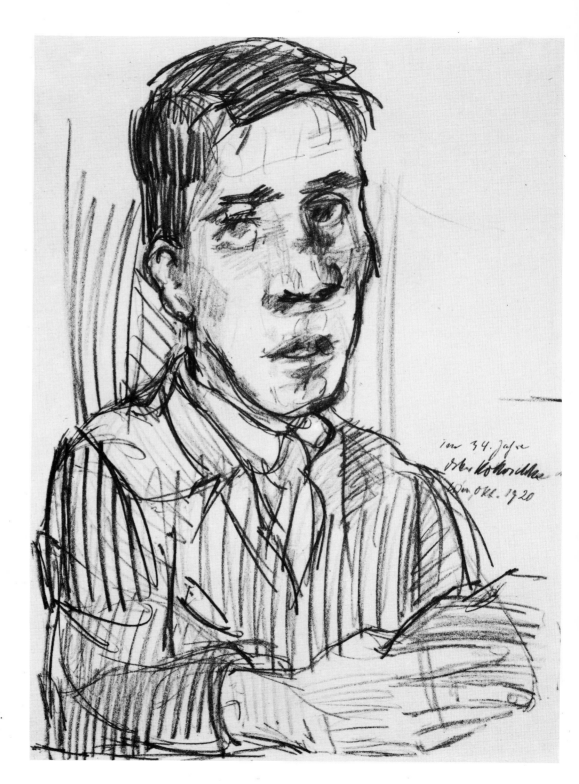

133
Self-portrait, 1920
Selbstbildnis
Charcoal
70.0 × 50.0
Inscribed: *Im 34. Jahre /
Oskar Kokoschka / Wien,
Okt. 1920* [In his 34th year.
Oskar Kokoschka. Vienna,
October 1920]
Private collection

174